SPECIAL THANKS TO OUR EXHIBIT CATALOG SPONSOR

A generous #waterislife artist who loves and respects our planet and has donated generously to environmental causes that effect us all.

Catalog Design by Indigo Perez
indigosportfolio.tumblr.com
and
Judy Coates Perez

The Artist Circle presents "Threads of Resistance,"
a juried exhibition of fiber art created to protest the
Trump administration's actions and policies.

We seek to address current issues including climate change, sexual assault, immigration, the refugee crisis, racism, and sexism. The art in this exhibition expresses a range of emotions from anger and sadness, to our hope for positive change.

Through much of history, quilts have spoken to many political causes, including the temperance movement, women's suffrage, nuclear proliferation, and AIDS awareness. Quilts have always been a means of expression for people whose political voices were silenced.

Art is about communication, and the makers of these works are eager to share their viewpoints. Agree? Disagree? We invite you to join us as we examine these issues and consider differing opinions with civilized, constructive conversation. We hope to ultimately gain a better understanding of one another's perspectives and to foster continued change in a positive direction.

Curated by the Artist Circle Alliance: Sue Bleiweiss, Susan Brubaker Knapp, Judy Coates-Perez, Jane Dunnewold, Victoria Findlay Wolfe, Jamie Fingal, Lyric Montgomery Kinard, Melanie Testa, Leslie Tucker Jenison, Kathy York

WWW.THREADSOFRESISTANCE.COM

NEVERTHELESS, SHE PERSISTED

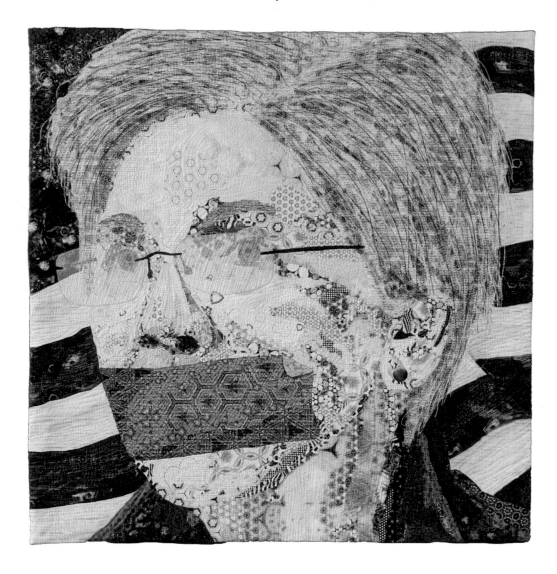

34" x 34"

DAWN ALLEN

My senator from my home state of Massachusetts, Elizabeth Warren, was reading a letter on the senate floor when she was silenced by Sen. Mitch McConnell. She was asked to leave and in that moment, I felt like I had been left without representation. I called my father in a panic, "Is this the beginning of the end?" When asked about the incident by a reporter, Mitch McConnell stated, "She was warned. She was given an explanation. Nevertheless, she persisted." That quote was in an odd way so encouraging. I am represented by a woman who persists!

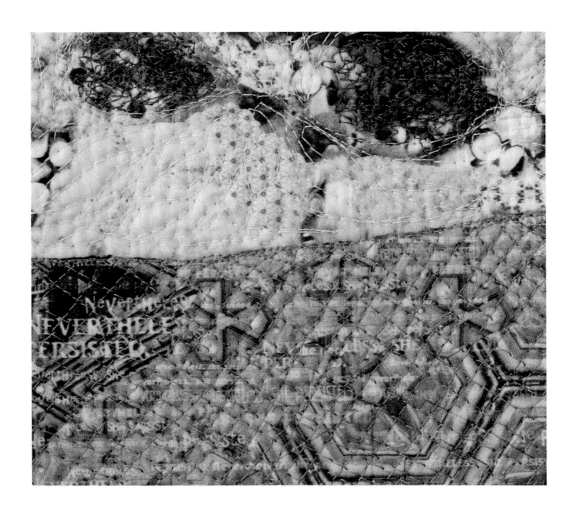

DAWN PATROL

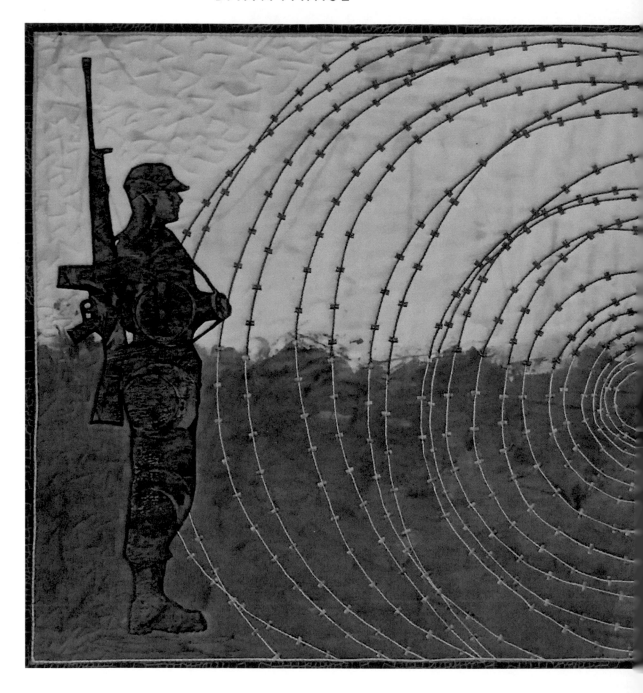

33" x 22"

JULIA M. ARDEN

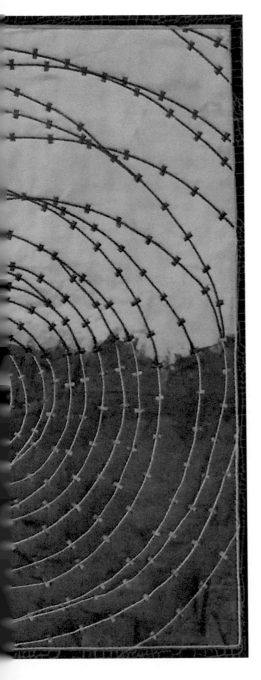

The shadow of jackboots beside razorwire does nothing to make us feel safe. It only engenders fear and creates an illusory "otherness."

REITAN¢E

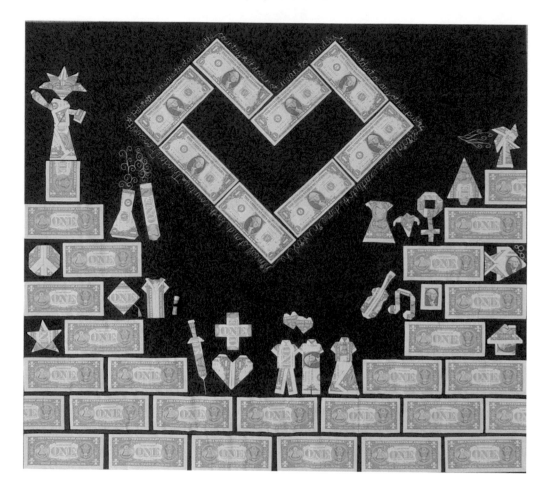

39" x 34"

MEL BEACH

Dear Donald Trump,

American citizens are speaking out to express our significant concerns with regards to your administration and policies. To date, we've mailed postcards and letters, made phone calls, communicated with our United States senators and congressional representatives, signed petitions and organized rallies and marches – all of which have been dismissed by you and your administration. Since you'd rather think like a billionaire than act like a public servant, let's utilize the one item that has consistently received your attention: Money, Money, MONEY!!

Now that I have your attention, I would like to express my profound disapproval of your determination to build a wall along the U.S./Mexico border. Not only will this place a huge financial burden on those who actually pay federal taxes, but it will do little to address illegal immigrants entering the United States. Instead, let's reallocate more of the federal budget into programs and policies that will truly make America great including:
· Immigration policies and support for refugees (Statue of Liberty)
· Fund science (beaker & test tube)
· Build bridges with world leaders to work towards peace (peace sign)
· Support our veterans (star)
· Invest in education (mortar cap, gown & diploma)
· Provide affordable health insurance (vaccination, first aid and heart)
· Protect LGBTQA rights (paper dolls depicting gay couple and transgender)
· Create affordable housing (house)
· Fund the Arts (guitar, music note & painting)
· Preserve our environment/natural resources (fish & tree)
· Respect women's rights (dress, uterus & female symbol)
· Invest in renewable energy (windmill)

The country is speaking up and I hope you will listen and start standing by the country and its citizens vs. your own self-interests, your family, the Trump organization, your business associates, and other questionable affiliations.

Sincerely,
Mel Beach
A proud registered voter who is eagerly awaiting the 2020 presidential election

FEEDING TIME AT THE SWAMP

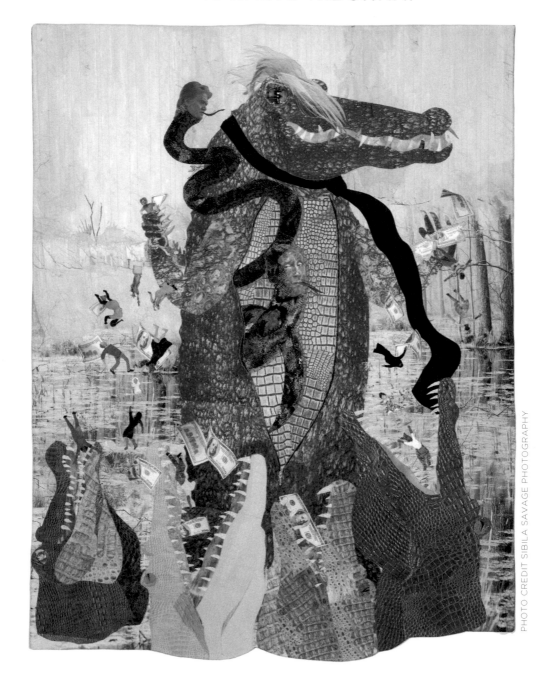

48" x 60"

ALICE BEASLEY

Far from "draining the swamp," the Alligator in Chief has staffed his cabinet and administration with billionaires, Wall Street insiders, alt-right snakes, Russian cohorts and wealthy campaign contributors all eager to feed off the rest of us.

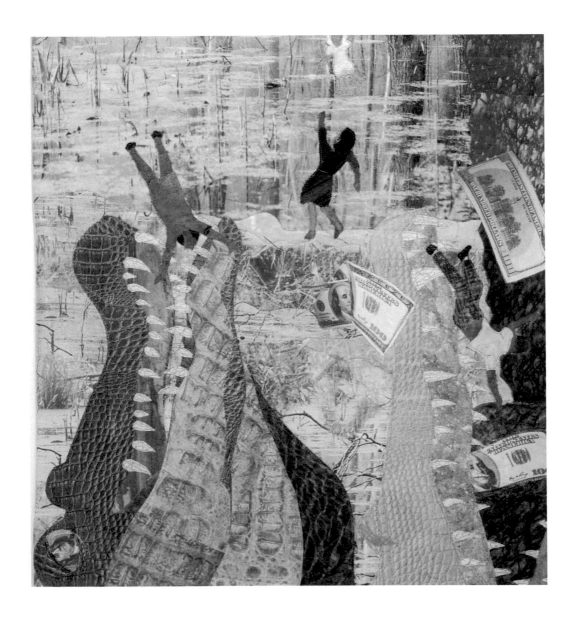

LIBERTY MARCHES

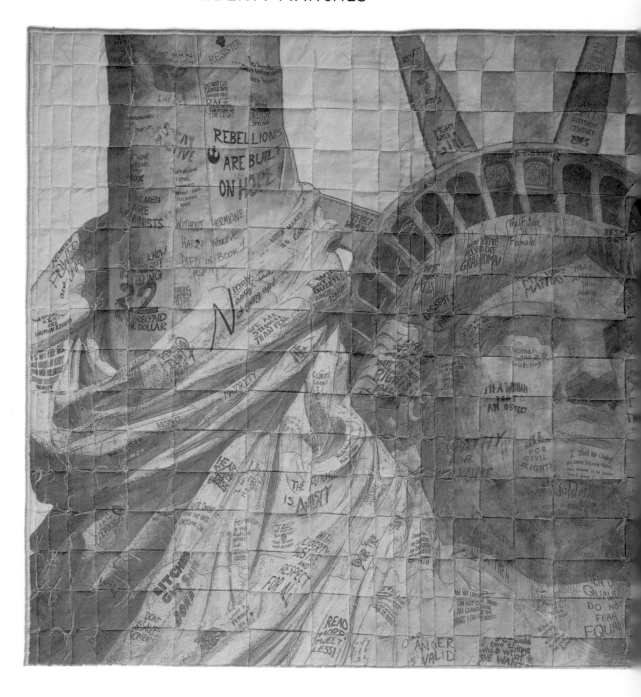

36" x 24"

SUSAN BIANCHI

On Jan. 21, 2017, the Women's March took place around the world in protest of the character and policies of the 45th president of the United States of America. Women and men marched in support of many issues including liberty for all human beings.

The symbol of our country's freedom commonly known as the Statue of Liberty is actually entitled Liberty Enlightening the World. Libertas carries a torch in her right hand lighting the way forward, a tablet in her left inscribed with the date of our declared independence, and a broken chain at her feet symbolizing abolition. I imagine her on Jan. 21 wanting to march but knowing how much more important it is to hold high the symbols of freedom. She invites more than 100 marchers from all over the world to make the signs they march with a part of her. Emblazoned with their words, she re-enlightens the world.

We can help. The fabric of liberty is imperfectly woven together. Sometimes it frays and unravels and hangs by a thread. We can strengthen the cloth. Working together, marching together, we are liberty.

MY BODY MY RULES

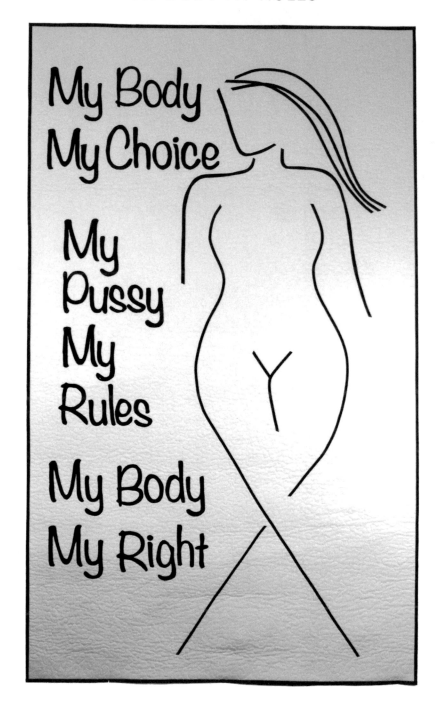

35" x 60"

SUE BLEIWEISS

My body
My choice
My pussy
My rules
My body
My right
No more need be said
It's not up for debate

MY FLAG, OUR COLORS

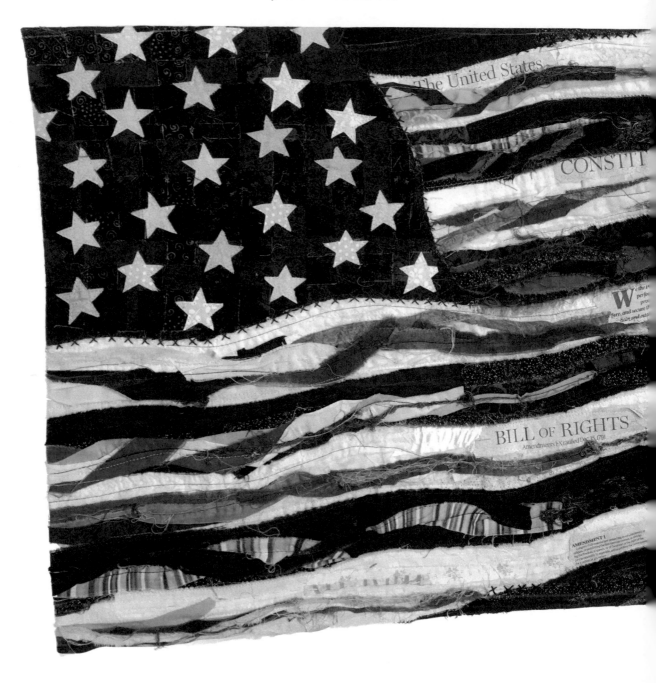

29" x 21"

MARY L. BOLTON

Channeling Betsy Ross, I took up my needle and thread. Looked into the fabric collection and thought: What would Betsy use if she were making a flag for us today? I thought, not just three colors and it wouldn't be so neat! We are a multi-colored nation and my flag would be made from many colors, torn and tattered to represent the struggles of a diverse people. Woven in places, because united we are STRONG. And stars, yes, still use the stars, to represent HOPE. And that purple heart? Well, that doesn't need explanation.

THE DISGRACE – WORDS AND DEEDS

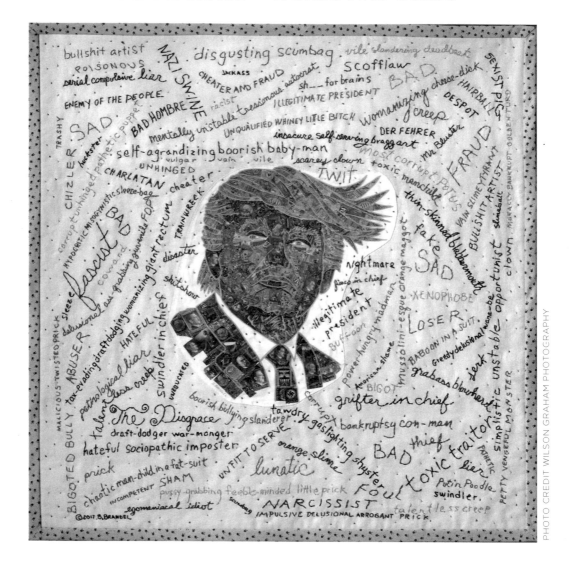

34" x 34"

BARBARA BRANDEL

Once upon a time there was a bratty little boy who was very white, and not very bright. His family was rich, so he thought he was special. He thought he was a prince. The bratty boy bragged, offended, stiffed, slandered, assaulted, and threatened everyone around him but mostly girls and brown-skinned people. He THOUGHT he should be king.

Most villagers saw him as a blustering bully. But the unsure thought when he promised things, he could grant their wishes. He pretended he knew things, how to solve their problems. He promised many people different things, and even convinced some that if they gave him money, he would grant their wishes. He started to BELIEVE he COULD be king.

Sometimes he said and did awful things, hurting people, ruining lives. He had practiced lying and cheating for years, and he was good at blaming others for his deeds. He could create a tornado of confusion in peoples' minds. He attracted lots of attention, and he LOVED that. He was still a little boy at heart.

He blustered on about everything he could think of to become king. Bad, selfish things he believed, that he thought other people secretly believed.

The little boy didn't know the names of the things, because he was always a little confused. He called it all "Making Things Great Again". He ordered a crown.

Long story short, the brat DID become king, made huge messes everywhere, and didn't understand anything important. He just wanted lots of attention, and his empire to fatten at everyone else's expense. His words and deeds defined him.

We don't know how the story ends, but the RESISTANCE to his reign kept marching, writing, working, speaking, art-making, knitting, and stitching for Truth and Justice and Equal Rights for ALL.

GAME OVER

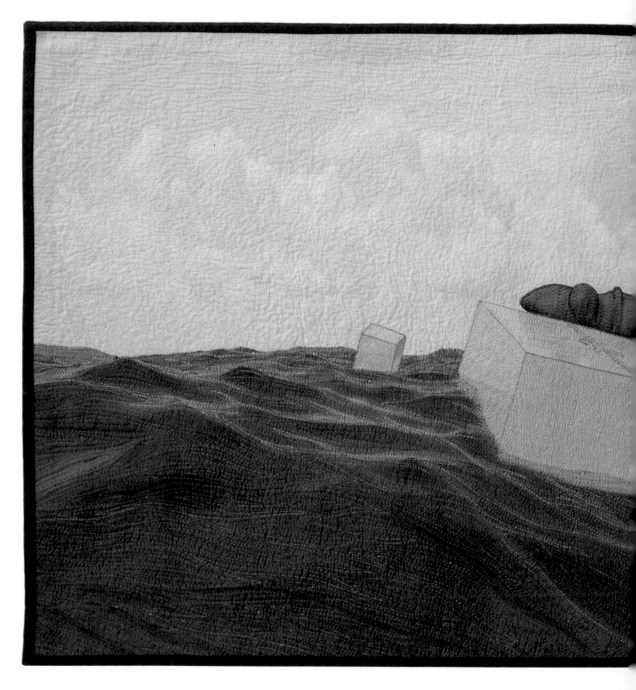

33" x 20"

TANYA A. BROWN

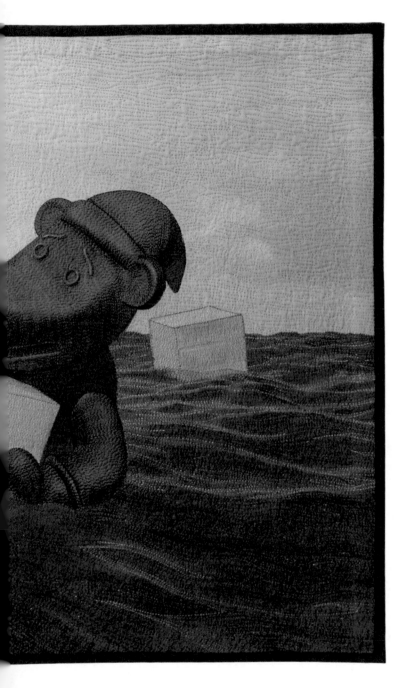

Many Americans, including the current president of the United States, don't believe in the reality of global climate change. Many polar bears disagree with that conclusion.

Donald Trump has repeatedly stated that he believes global climate change is a myth invented by the Chinese. His administration is currently working hard to dismantle much of the work on climate change enacted by previous administrations. This includes a chilling suppression of information on the topic, reminiscent of the falsification of photos and information during Stalin-era Russia. However, denying reality will not make it go away. It will only make the consequences far more serious.

"Game Over" was inspired by a classic children's game in which players take turns tapping plastic "ice blocks" out of a frame. The game ends when one of the players "breaks the ice," sending a polar bear game piece plummeting off its ice floe. The game, with its playing pieces made from the same petroleum we burn as fuel, encapsulates the changes humans are making to the environment.

GUSHER

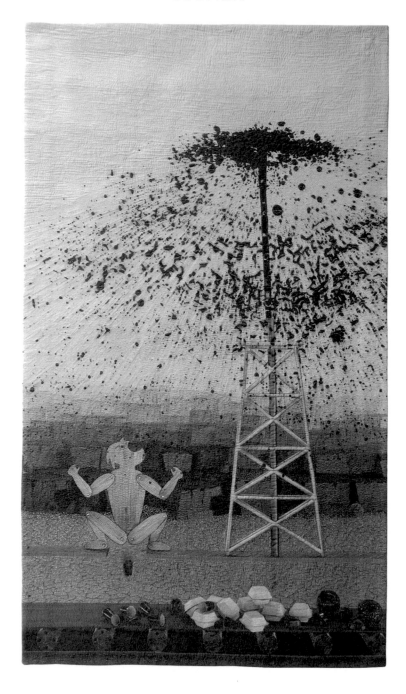

22" x 39"

TANYA A. BROWN

With the appointment of a secretary of state from Exxon/Mobil and an EPA head with close ties to the fossil fuel industry, the Trump administration is in the process of shaping America's foreign and domestic policies for the benefit of the oil industry.

Trump has further shown his support for this group by signing an order to dismantle environmental regulations, claiming this will trigger a new energy boom. As The Washington Post put it, "the order (sends) an unmistakable message about the direction in which Trump wants to take the country – toward unfettered oil and gas production, with an apathetic eye to worries over global warming."

Trump has expressed outright contempt for clean energy and those who value it, saying, "There has been a big push to develop alternative forms of energy – so-called green energy – from renewable sources. That's a big mistake. To begin with, the whole push for renewable energy is being driven by the wrong motivation, the mistaken belief that global climate change is being caused by carbon emissions. If you don't buy that – and I don't – then what we have is really just an expensive way of making the tree-huggers feel good about themselves."

"Gusher" represents the damage and waste caused by the unfettered use of oil and fossil fuels for supporting our consumer lifestyle. The backdrop of "Gusher" is a wasteland of parched soil and trash-strewn hovels. Humanity has been reduced to an automaton that excretes a never-ending diarrhea of red, white, and blue plastic crap. "Gusher's" unsustainable, greed-driven economy has resulted in a world comprising waste and pollution.

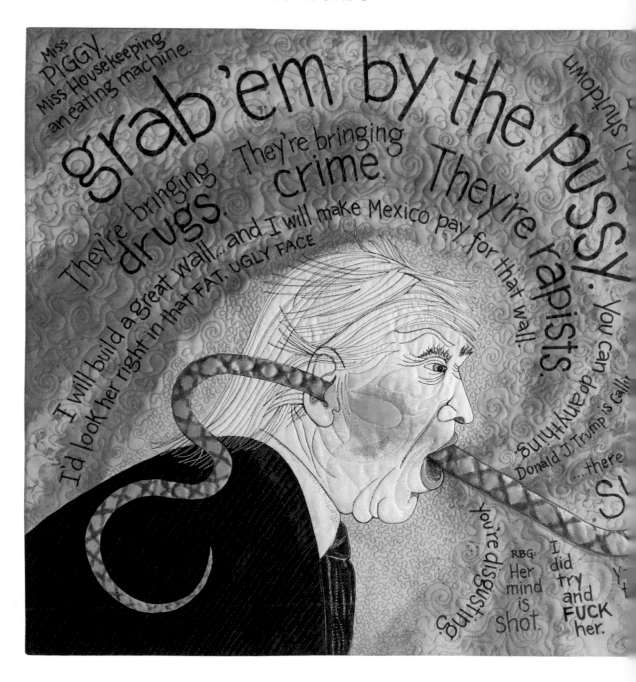

34" x 23"

SUSAN BRUBAKER KNAPP

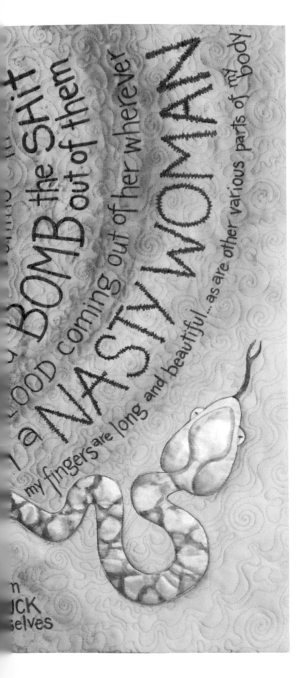

I was greatly disturbed by things Donald Trump said during the presidential campaign, and by the words he used. It was amazing how many women I know who were horrified to hear people using the word "pussy" or talking about pussyhats, but who brushed off Trump's "grab 'em by the pussy" comment as "boys will be boys," or "locker room talk." So much of what came out of his mouth were racist, misogynistic and xenophobic insults. For our democracy to succeed, and for us to solve vital problems our country faces, we must be able to discuss important issues with civility and respect, to listen to others' views without insulting, even if we completely disagree. Finding common ground – even a small patch of it – is impossible without this. If these kinds of comments are considered acceptable for our president to say and tweet, then they become acceptable for others. They are a poison that infects us all. I believe that the rise in hate crimes, as documented by the Southern Poverty Law Center and other organizations, is a direct result. Words often lead to actions. The poison is spreading …

25

ZAHRA, AGE 5, SYRIAN REFUGEE

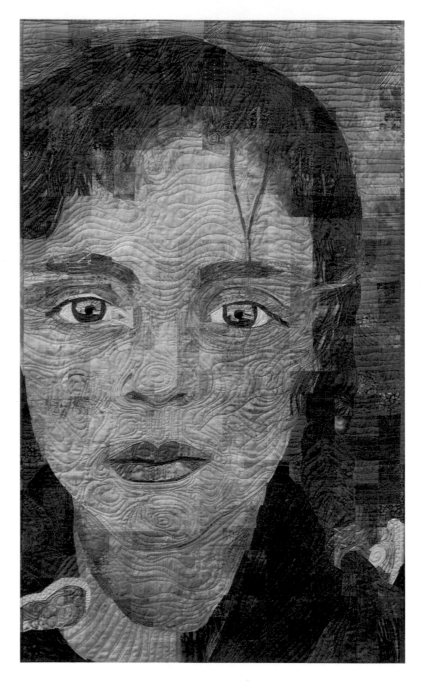

34" x 58"

SANDRA BRUCE

When I first saw the photo of Zahra, taken by Muhammed Muheisen, I knew I would have to make a quilt of her in my Matrix technique. Her face, and especially her eyes, say so much about what she has endured in her young life, and I wanted to capture it in fabric. The children of Syria have suffered beyond belief, and as a mother my heart goes out to them. Her pink hair ties remind us that despite her plight, she is merely a small child, who deserves a childhood, as all children do. The quilt contains approximately 500 2-inch squares, many of them pieced. Photo used with permission from The Associated Press.

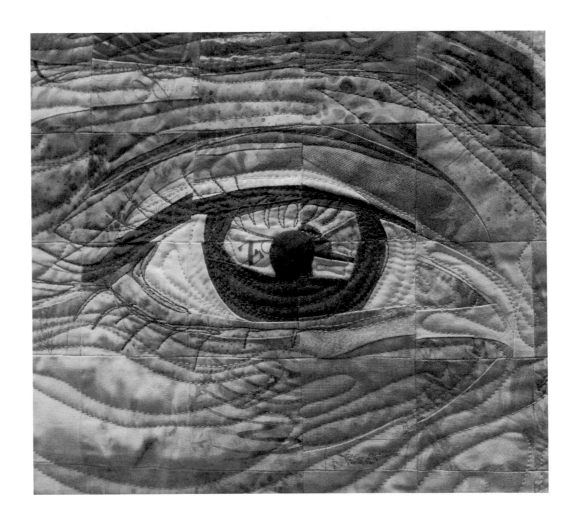

SHE PERSISTED

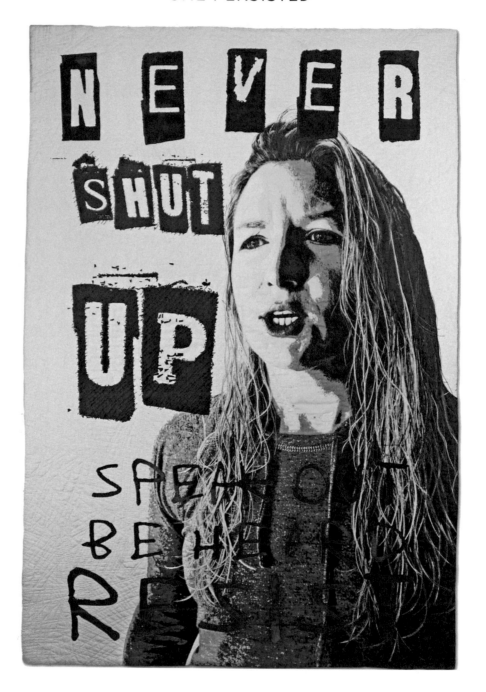

32" x 48"

BETTY BUSBY

Women have been told for millennia to sit down and shut up. The struggle for rights in the Western world, initiated by the suffragettes demanding the right to vote, and continued by various organizations since then, has recently been dealt a severe blow by reactionary forces in the U.S. In many other areas of the world, conditions for women remain at a medieval level. This work is meant as encouragement to stand up and be counted, not only for your own rights, but for those of others and future generations.

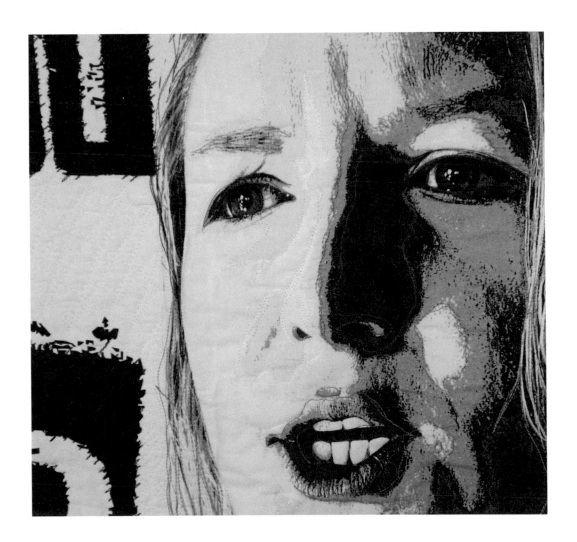

LADY JUSTICE

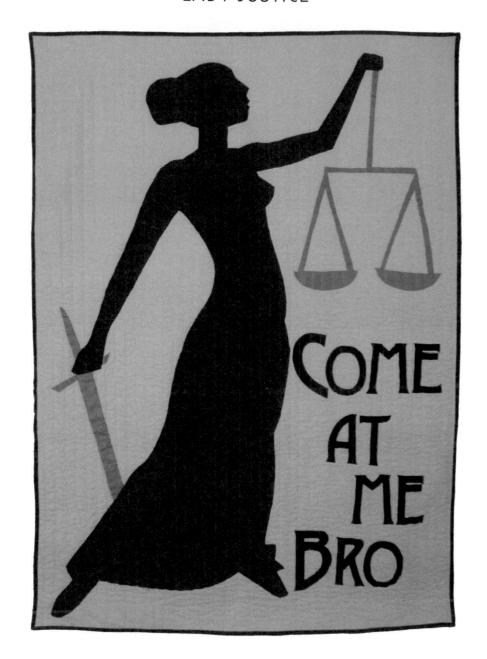

42" x 59"

ALLISON CHAMBERS AND EMILY ROBBINS

First in reference to the 9th U.S. Circuit Court of Appeals' decision to uphold U.S. District Judge James Robart's block on his travel ban, and then again when a U.S. district judge blocked his executive order withholding funds from sanctuary cities, Trump's response on Twitter has been: "See you in court." We decided that the best response to Trump's bombastic tweets would be to create a piece that essentially says, "Bring it on." Utilizing raw-edge appliqué, we created a strong, powerful Lady Justice who stands in a defiant and self-assured manner, representing our confidence in the judicial system to fight against attacks on our rights.

THE KISS

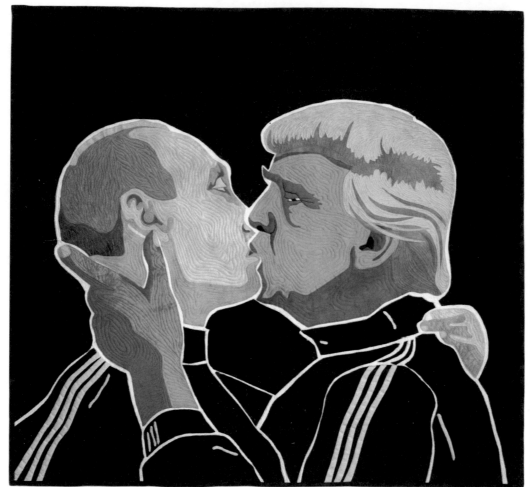

39" x 36"

MARYTE COLLARD

I am an American citizen living in Lithuania. I love America and I care about what is happening there and I care about the future of my country. That's why I didn't vote for Donald Trump. But even more importantly, I didn't vote for Donald Trump because of what his presidency looks like from here.

The idea that Putin may have helped Trump to win an election and to become a president worries and scares me. It worries and scares not only me, but most Europeans, especially those living in Baltic countries. Finally we are free and we don't want to go back under the yoke of Russia. We don't want to experience the destiny of Crimea. It is possible because we have a border with Russia. It can also be possible because of the romance between President Trump and President Putin.

Trump's romance with Putin lately has changed to a theatrical standoff as an attempt to cover up the romance. Either romance or an extreme confrontation will not make the world a safer place and will not make us here safer as well. President Trump must understand that Russia has never been a friend of the United States of America. It looks like he can't see this simple truth from America but we can clearly see it from here.

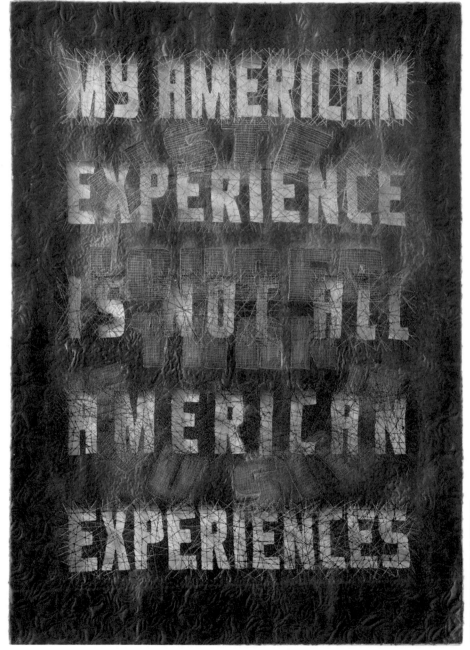

30" x 42"

SHANNON M. CONLEY

What do I want to say? That climate change is real and we need to take responsibility for it? That if we don't protect our environment and natural resources now, our children won't have anything left to protect in the future? That evidence-based science should inform policy? That immigrant rights are human rights? That feminism isn't a dirty word? That implicit bias is real and ignoring racism won't make it disappear? Yes, yes, yes to all of that. But more overarchingly, I want to say that my (and your) American experience is not all American experiences. That good leadership requires recognizing that those you serve don't have the same needs and perspectives as you do. Stop conversing with only those who think like you do. To quote our choir director: "Listen louder than you sing."

DEATH OF SCIENCE

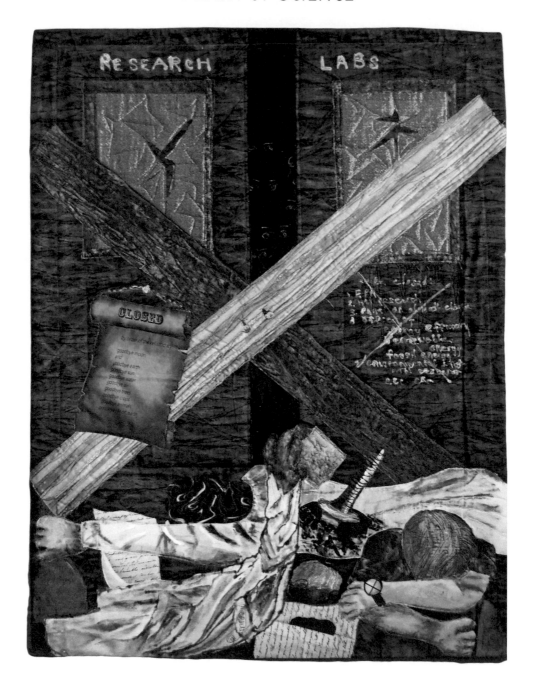

28" x 37"

PHYLLIS A. CULLEN

The staggering ignorance, incompetence, greed, of this incredible kakistocracy of ridiculously and tragically unsuitable administration appointees have led to an abundance of proposals and dictates that threaten to roll back environmental, medical, climatological and other scientific research and protections. They threaten the well being and existence of humans, animals, and the earth itself.

NOT SO SAFE

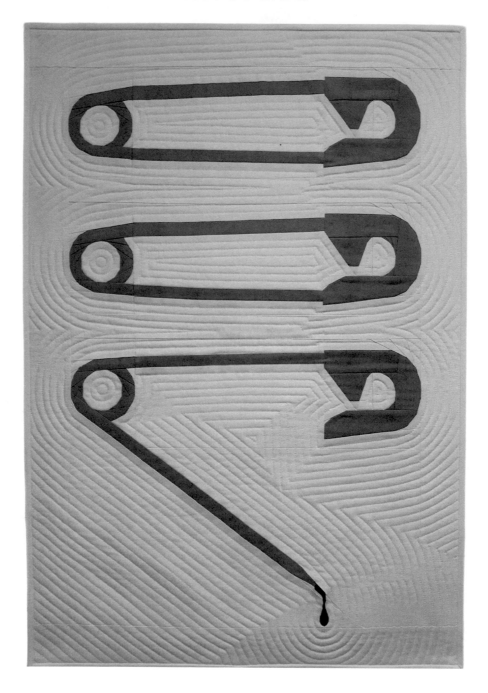

22" x 32"

AMY DAME

After the Nov. 8, 2016, election of Donald Trump as the 45th president of the United States, a trend emerged on social media. Wearing a safety pin was celebrated as an easy way to show support for those negatively affected by his win, and the idea spread rapidly.

Those in favour of the concept claimed that a simple safety pin attached to one's coat would show that person to be a "safe space" for people who were being further marginalized by Trump and his followers. As the idea grew, even people who voted for Donald Trump celebrated it as a way to show the world that the wearer was "still a good person," despite voting to limit or deny the basic human rights of others.

People who were actually affected by Trump's racism, misogyny, homophobia, Islamophobia, ableism and more were less enthusiastic. While certainly some People of Colour (POC), immigrants, LGBTQ, or Muslim people appreciated the thought, many more questioned why a true ally would need a visible symbol of their support for human rights. Wouldn't they be visible as an ally because of their actions? Wouldn't marginalized people learn that they were trustworthy because the person has been taking actions and speaking out against oppression as they witness it?

Oppressed people know all too well the history of well-meaning allies who claim to support them, while simultaneously keeping quiet, refusing to take actions that might endanger their privilege, or outright causing harm to the people that they purport to protect.

While many of the people who wear safety pins may have the best of intentions, marginalized people have no way of knowing which of those safety pins will pop open and harm them, which means that the safety pin movement really doesn't symbolize anything other than the guilt of privileged people looking for forgiveness from those who are oppressed.

OUR FRACTURED HOMELAND

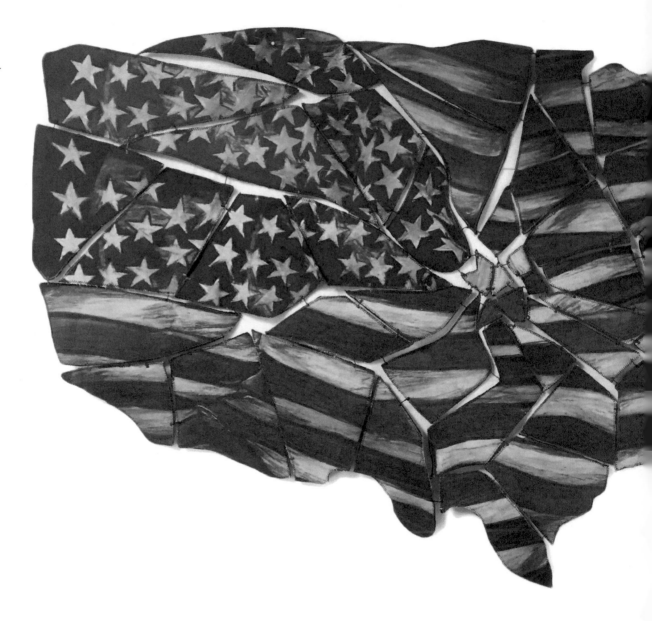

47" x 32"

TRICIA P. DECK

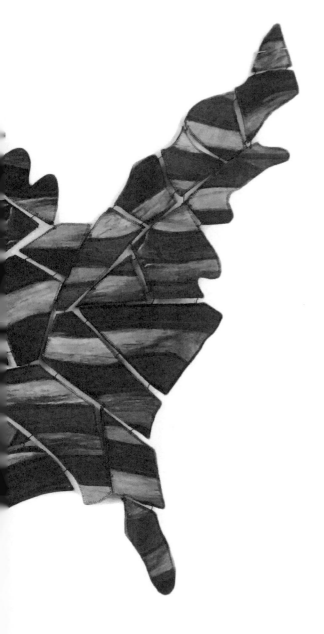

Today's political climate is like nothing we have ever seen. There is so much uncertainty and fear about what will happen. Our political parties are only fighting against each other, with no apparent hope for resolution. Neither side is willing to work together in a bipartisan way. I created my quilt with the visceral fear and realization that our country is fractured! I drew our country's borders and fractured it from the heartland.

Eliza Deck created the original drawing of the United States that I had printed at Spoonflower

TEARS FOR AMERICA

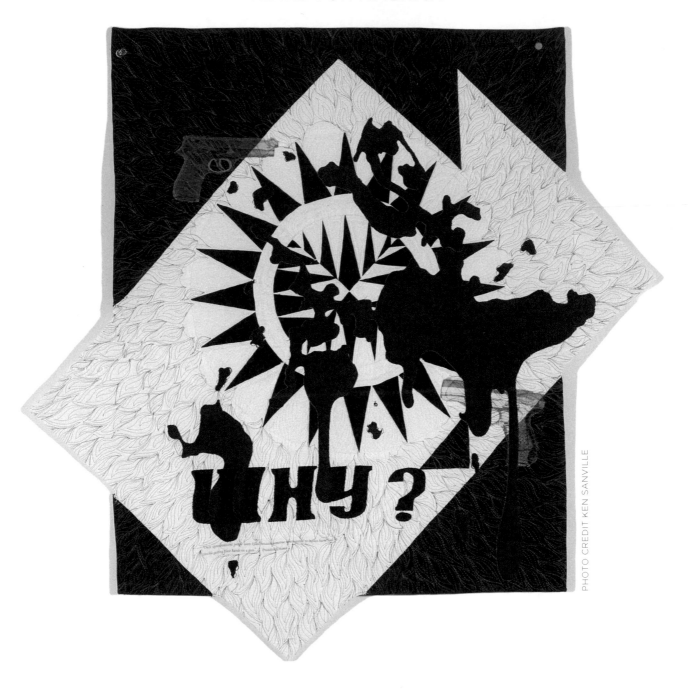

29" x 29"

REBECCA FELLOWS

Guns and gun violence have intruded into our daily lives. Nowhere is safe. Mass shootings, violence against women and "accidental" deaths of children by unsecured guns is rampant. Gun rights enthusiasts want guns everywhere – schools, churches, parks, theaters. And gun rights politicians refuse to let the CDC study gun violence as a major health problem. My question is "WHY?" Why do we need guns everywhere? Why guns in schools? Why guns at the grocery, in the workplace, at the movies, on playgrounds? Why?

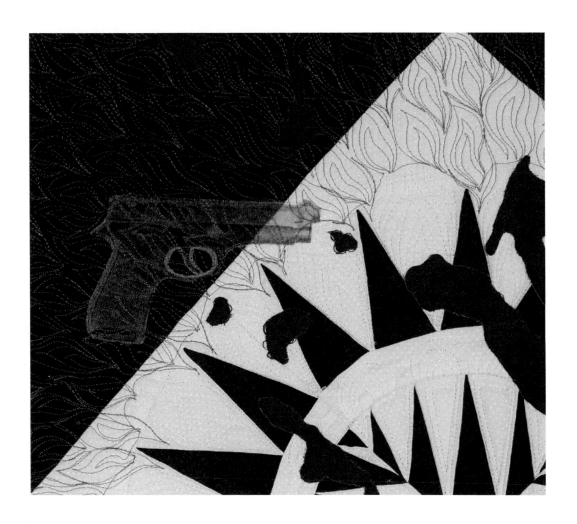

100 DAYS

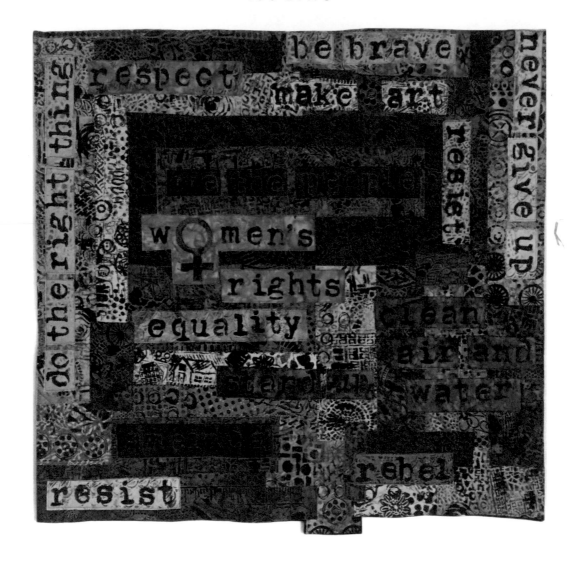

31" x 31"

JAMIE FINGAL

100 days of pure outrage every day. Something different and outrageous with fake news, alternative facts and issues that shook the core of my being. I got up and got involved in the fight. These words have stuck with me, the things that mean the most. I shake my head every day at the bait and switch and the tearing apart of our country. Call your representatives and let your voice be heard.

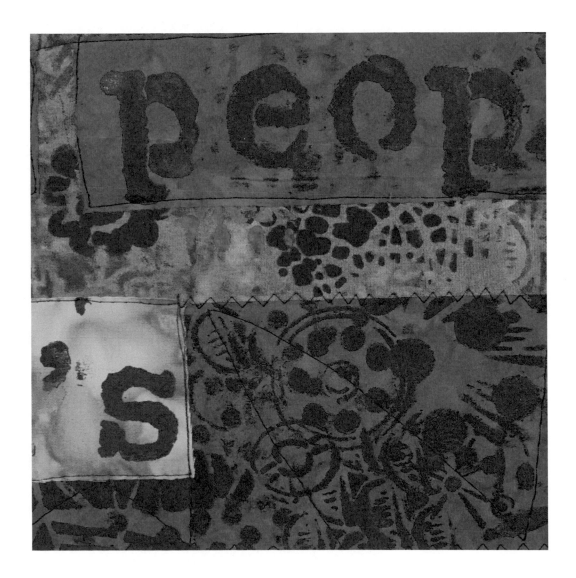

SPEAKING OUT

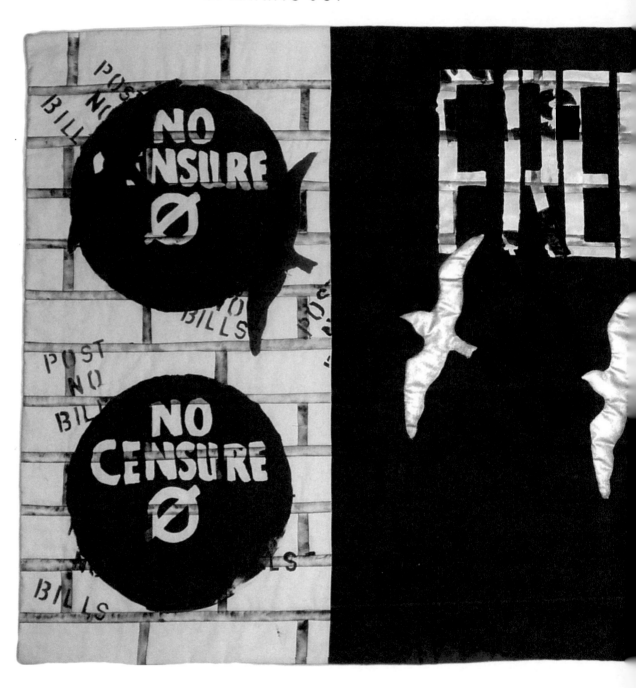

36" x 24"

LINDA L. FRIEDMAN

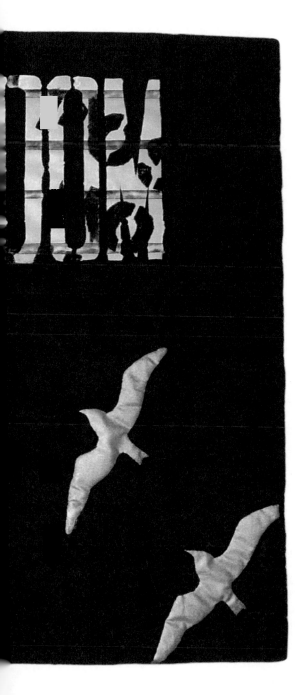

This work seeks to underscore the sacrosanct nature of our freedom to express ideas, beliefs and opinions without censorship, limitation or obstruction.

EQUALITY

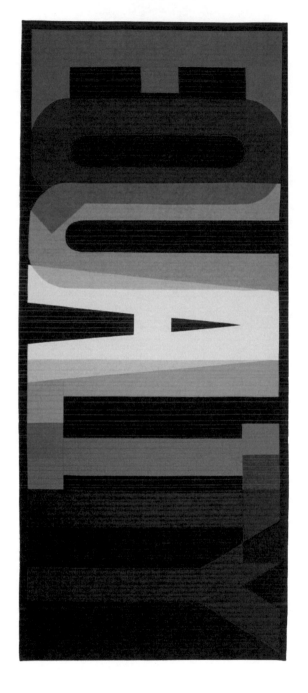

25" x 60"

KERRI GREEN

I chose the word EQUALITY, blazoned in the colors of the rainbow flag representing LBGTQ rights, to be a positive symbol of virtue and hope for our politically divided society. The original flag, designed by artist Gilbert Baker included eight colors. Pink represented sexuality; red was life; orange was healing; yellow was sunlight; green was nature; turquoise was art; indigo was harmony; and violet was the human spirit.

DEAR MR TRUMP

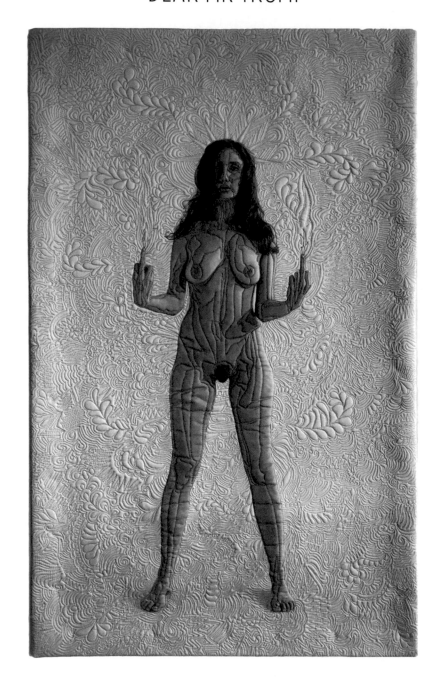

20" x 33"

NEROLI HENDERSON

Dear Mr. Trump,
Here's my pussy and you can't grab it, I don't care how rich you are. I'm naked but you can't sexualize me. I'm not your honey and never will be. I'm more than a collection of my parts. I'm standing here with my legs spread telling you that I'm your equal. You don't speak for me. You don't stand for me. You don't represent what I represent. My body, my choice. And so Dear Donald…go fuck yourself. It's only society's own perceptions of sexuality and nakedness that skew the concept of what amount of skin is OK. How can we move forward towards true equality when we elect a man into the highest office in the world who has openly spoken about objectifying and mistreating women? It sends a message to males everywhere that behaviour of this sort is acceptable. I for one am sick to death of hearing how women taunt men into sexual assault through how they dress or what they do, when the onus should be on men behaving better.

Various words are stitched into the background of this piece, including: "Nice Girls Don't," "Eat Your Words," "Trust Me" and "Think."

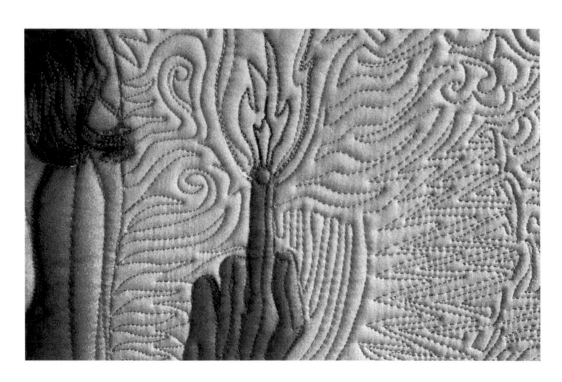

FLINT WATER

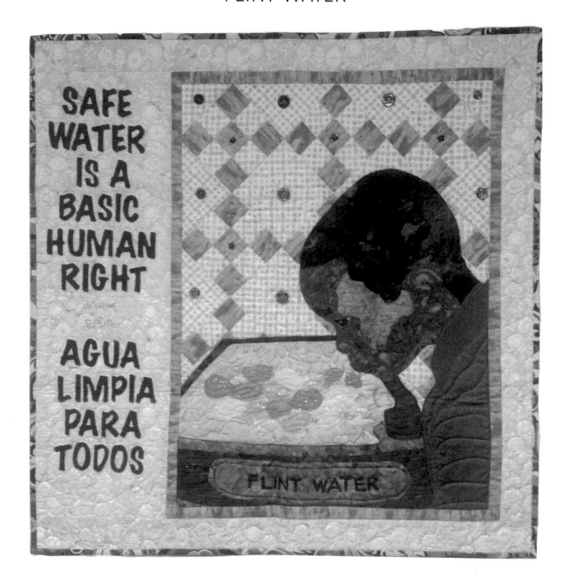

35" x 35"

SYLVIA HERNANDEZ

I made this quilt to bring attention to the poisoning of the water in Flint Michigan and the lack of interest in fixing the situation. I wrote a message in Spanish because immigrant families were not given bottled water from the government because they did not have ID.

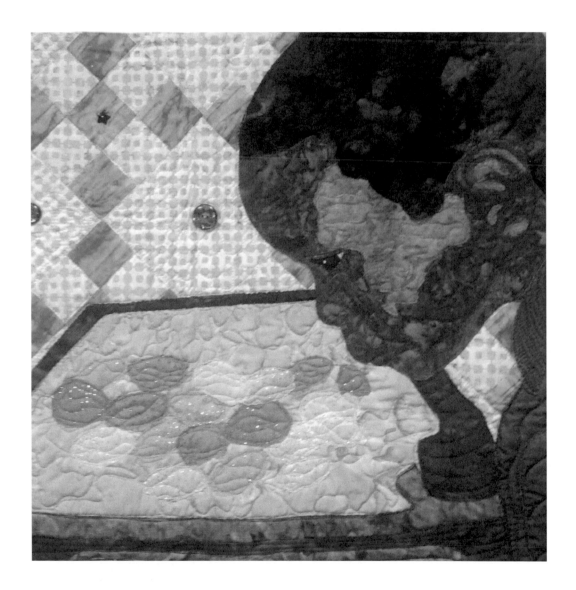

FALSE DICHOTOMIES (I DON'T FIT IN YOUR BOX)

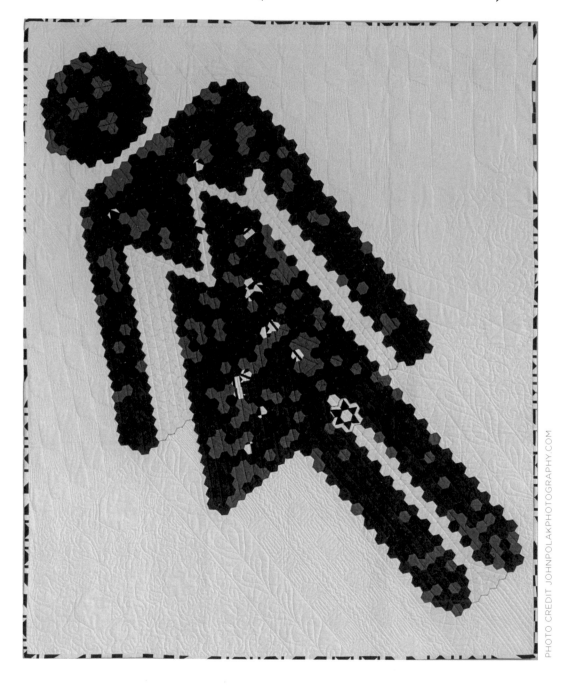

47" x 59"

AUDREY J. HYVONEN

"False Dichotomies (I Don't Fit in Your Box)" explores the pervasive black and white thinking of our largely gendered society and insists on thoughtful reflection to deepen or widen that thinking. Drawing from the traditional Victorian era, black and white hexagonal tiles resonate specifically with current bathroom access battles in this life-size work presenting a blended human figure composed of split iconic gendered bathroom signs.

The standard binary of female/male is challenged as a false dichotomy, marked in this piece by the "W" and "M" chest emblems altered into a zig-zag superhero shield; the "skirt" of the left-sided figure being referenced as a ghost cape on the right; and finally, the neutral genital flower, indicating a root that is gender free.

The angled placement of the figure on the background is both intentional and reactionary. Gender fluidity does not fit in the narrowly defined standard binary "boxes" created by society, and neither does this hexagonal human (h=68") fit into the show dimension restrictions (h=60"). Prioritizing the full figure meant a sideways mount at an awkward angle, paralleling the oft-challenging expression of an authentic self as faced by many nonconforming or transgender people in our culture.

We tend to categorize, perhaps as a way to make sense of things we don't yet understand. Recognizing and eventually celebrating the fullest continuum of existence and expression, in its complexity and diversity, is what will move us toward the most inclusivity and thus make us most beautiful as a society.

RESIST TYRANNY

42" x 45.5"

LESLIE TUCKER JENISON

The mantra, "Resist", has been a constant in my thoughts during and since the 2016 election cycle. How can we be the best citizens in this advanced democracy? How can we respectfully disagree? The idea of peaceful resistance, vigilance, and advocacy are at the forefront of my thoughts and actions. As a proud citizen of this country I view it as my responsibility to monitor my elected officials and resist the potential for tyrannical governance.

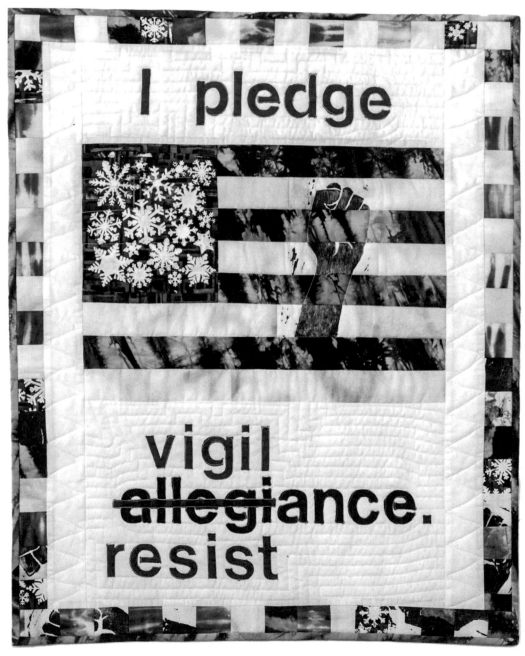

22" x 27"

SARA KELLY

It makes me very uncomfortable, under the trump administration, to recite the standard Pledge of Allegiance. Instead I wish to pledge resistance to the immorality, deceit, and divisiveness – and vigilance to recognize and protest wrongs whenever I can.

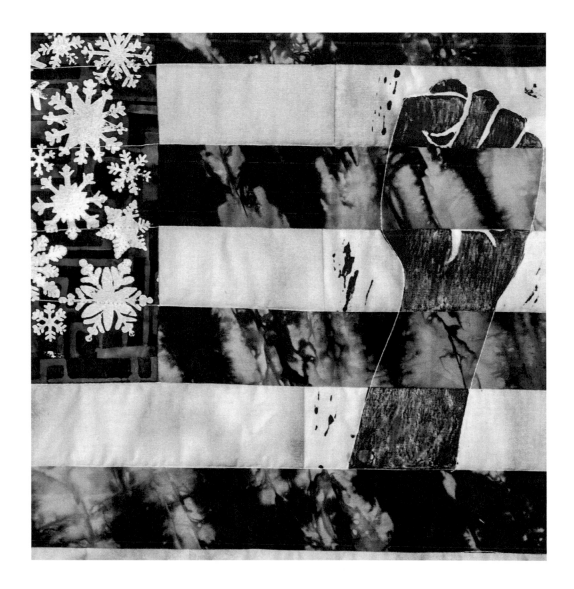

STILL YEARNING

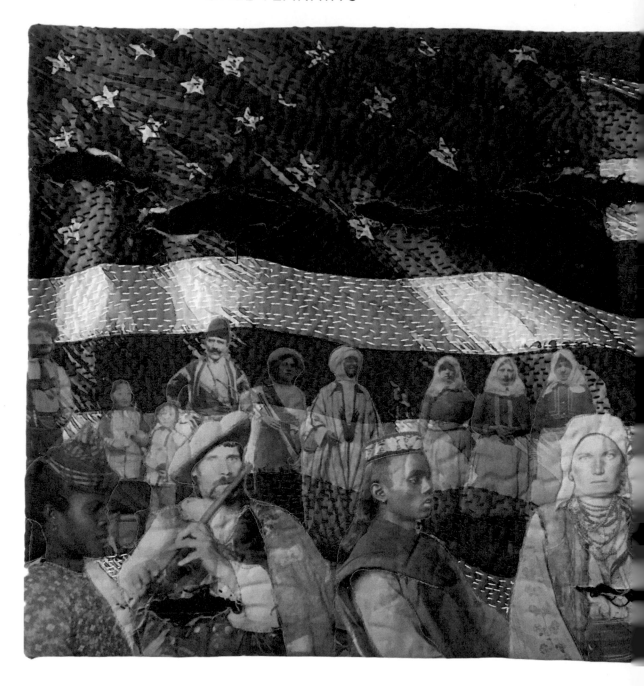

20" x 20"

LYRIC MONTGOMERY KINARD

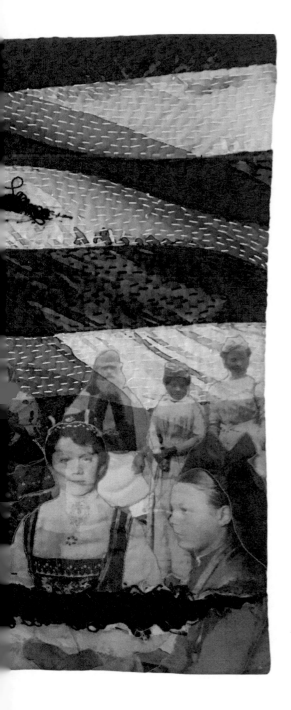

From its very inception, the privilege of citizenship in the Unites States of America has been denied to group after group, based on race and religion. African Americans were not granted citizenship until 1868, four years after the Emancipation Proclamation. Native Americans were not granted citizenship until 1924. Chinese immigrants were not allowed citizenship until 1943. We have turned away people after people who have sought refuge and opportunity. Now our leaders have chosen to vilify Muslims fleeing massacre and Mexicans seeking a better life for their children.

We as citizens can choose to better live the highest of our American values – "that all men are created equal." Through our individual actions and compassion we can stitch our country into a tapestry of great strength and beauty. Through our votes and civil dialogue and understanding of the data gathered by scientists, we can mend the tears in the fabric of our society.

Flag photograph by Stuart Seager used by permission; Immigrant photos by Augustus Sherman Manuscripts and Archives Division, The New York Public Library: public domain.

#NOTNORMAL

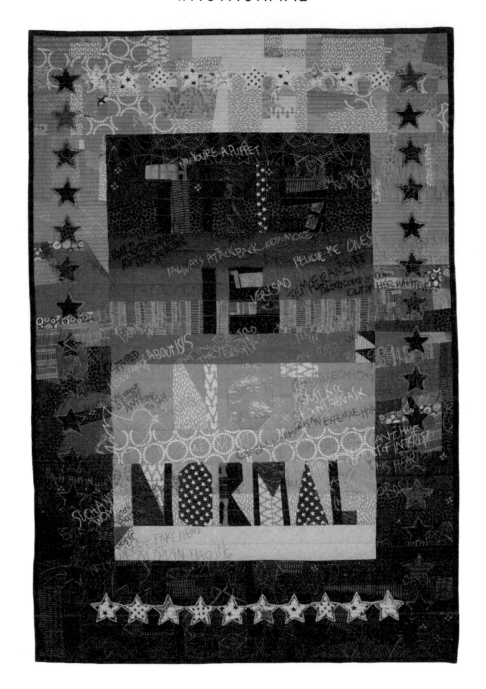

32" x 48"

KRISTIN LA FLAMME

Up is down and down is up. Lies and misdirection are commonplace. Tearing down the establishment is seen as progress. This piece calls attention to the normalization of Donald Trump's words and actions on his way to, and in, the White House.

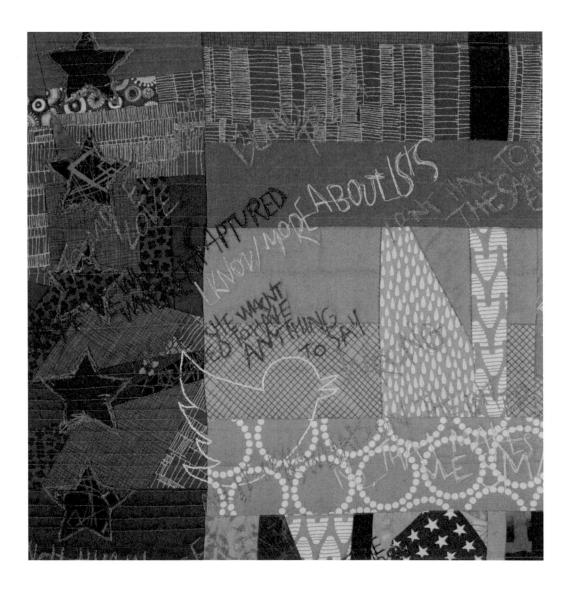

WORD POWER

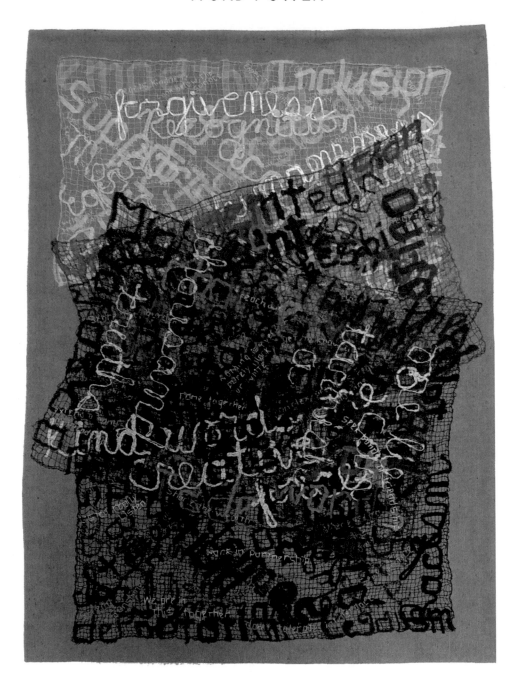

28" x 39"

ANN M. LEE

This work started with four panels of words recycled from a piece I created in response to Trump's campaign call for a border wall. The four panels represented:
• The power of words
• Words of welcome and acceptance
• Words of exclusion and hate
• Groups of people targeted and excluded

It was a 3-D piece with a looming black wall composed of dark hateful words that trap and obscure the color contributed by the diverse mix of people in this wonderful country and threaten to overpower the loving white words. Phrases and sayings about the power of words formed the base. Overall, I was trying to depict the power of words through this piece and how they can be forces for good or evil. Prior to the election, it was the negativity that the Trump wall represented to me that came through most strongly in the piece.

As I reworked the piece to convert it to a wall quilt, my eternal optimism came to the foreground again. As in all of life, the current political situation is a complicated mix of black, white and colors; good and evil. Each comes to surface at different times and circumstances. As I began stitching more words over the original panels, I found that I was creating a chronicle of my longing for harmony, cooperation, and working together. It became a call for digging in, doing the hard work of coming to compromise, and learning to really know and respect each other as human beings.

For many years now, creating art has often provided me with an outlet for coping with difficult situations. The Threads of Resistance show gave me a reason to put all my worries and concerns about our political situation into another artwork to stave off overwhelming anxiety.

EQUAL MEANS EQUAL

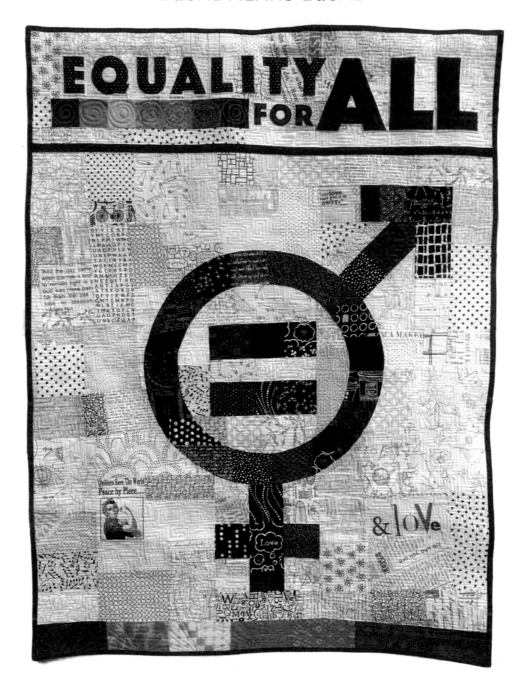

29" x 40"

JESSICA LEVITT

This quilt was created to be carried as a protest sign for The Women's March on Washington on Jan. 21, 2017. The making of the quilt was an outlet for me to work through the extreme emotions of disillusionment, anger, disappointment, and fear that I have been experiencing since the presidential election of 2016.

Choosing a message was a daunting task for me, as there were so many issues about which I want to stand and be heard. But, ultimately, the most personal for me is sexism. I believe in equality and rights for all people regardless of sex, race, religion, sexual preference, wealth or any other distinction you can come up with. I hope for a world where love and tolerance are normal, and fear and hate are diminished.

It was a surprise to me to discover that our Constitution does not have an Equal Rights Amendment (because it fell three states short of ratification) and that my rights as a woman are not protected within it. While the rights of women have come far since it was first proposed back in 1923, their protection in our Constitution is more important now with the current government in place and threatening to reverse many of them. If now is not the time, then when?

The quilt background is improvisational piecing with lots of meaningful details in the fabric to describe my resistance to the current president's agenda including: bicycle (for suffragettes), science, nature, love, music, safety pins, peace symbol, quotation marks, chaos, and words such as "start somewhere" and "Love." The reverse of the quilt is taken directly from a suffragette banner and expresses the power of standing together to be heard. The experience of going to the march and being part of the voice of millions was beautiful and empowering. I was proud to use my art to express my views and saw many who did the same. I'm grateful for the democracy we live in, and the freedoms I have that allow me to stand up and speak out. And … I am fiercely protective of them.

SPEAK TRUTH

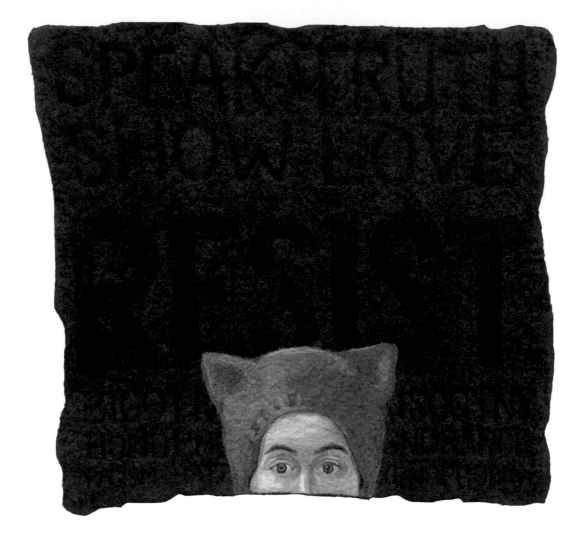

30" x 29"

KATHERINE H. McCLELLAND

As a middle class, white, cisgender female I am surrounded by privilege. I am guilty of being complacent. During Obama's administration I was happy to let others fight the battles, comfortable with the idea that those in power would put the welfare of the people first. This was a mistake. We are country built on the idea of government for and by the people. That requires us to be actively involved in that government. This piece is about becoming more involved in disrupting hate and supporting my fellow human beings. Marching with my 12-year-old daughter in Washington D.C. in January was an important and empowering moment for me so I chose to focus on an image of myself wearing the iconic Pink Pussy hat. I wanted the words to be present but not overpowering. To see all the text the viewer has to move around, change their viewpoint, and take a moment to read. In doing so, the viewer becomes more active and less passive.

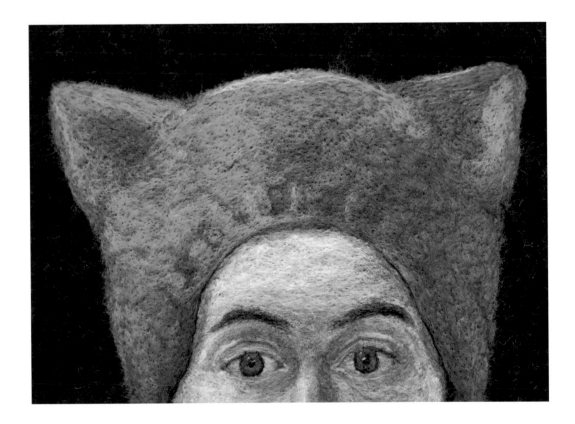

POLITICAL POWER GRAB

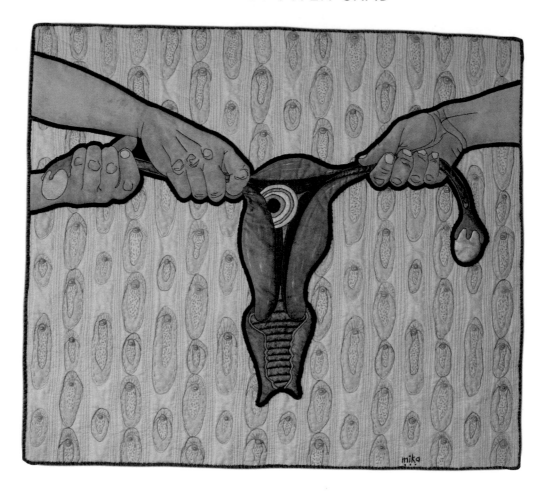

26" x 23"

SARA MIKA

I once saw a political cartoon with a preppy white man perched on top of a uterus. He was sarcastically saying, "Government should be small and unobtrusive so women don't feel it in their uteruses." Well, since it actually feels anything but, I've depicted three greedy political man hands fighting tug-of-war style over a uterus. In the background, I've illustrated what I'm coining #rankandfilepussies. Men expect us to fall in line and personify their vision for OUR bodies? Well, we proud pussies have news for them! We truly ARE sewn together with threads of resistance. Rank and file us and they'll soon find out that we not only have power in numbers, but that we bitches bite.

NEXT TARGET?

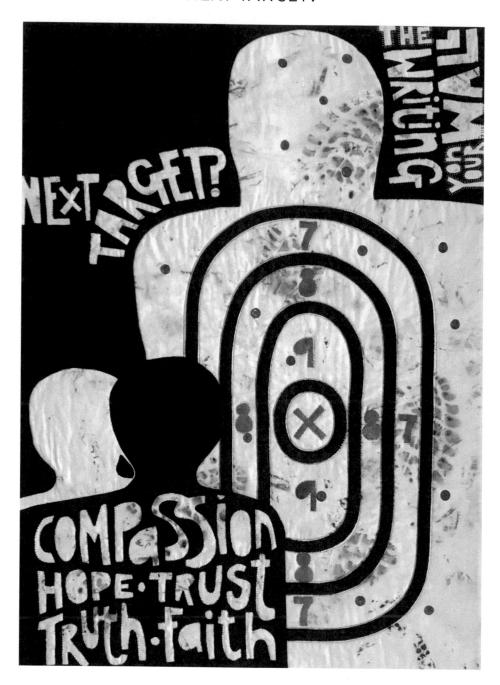

25" x 35"

GILLIAN MOSS

A piece made after hearing the news about the first person deported since Trump became president. A young woman called Garcia de Rayos was deported after checking in with authorities as she had been for the last 20 years. New rules meant she was deported to Mexico, a country she hadn't lived for at least 30+ years. She had to leave her husband and two children. She was made an example of! I made this piece initially with such anger but once I started, I realized it felt like a stone had been lifted off my chest.

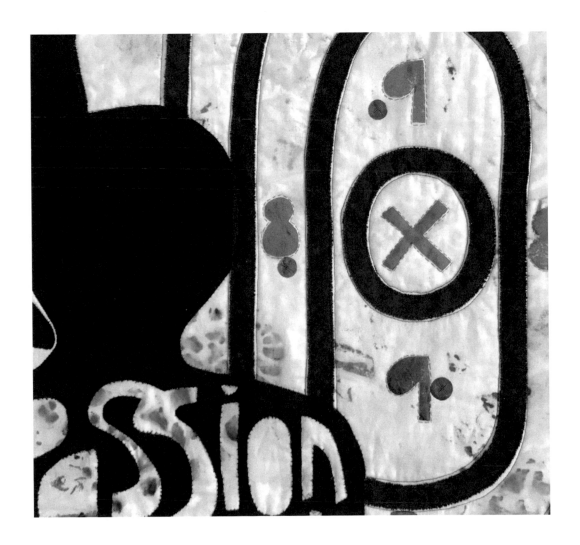

HANDS OFF!

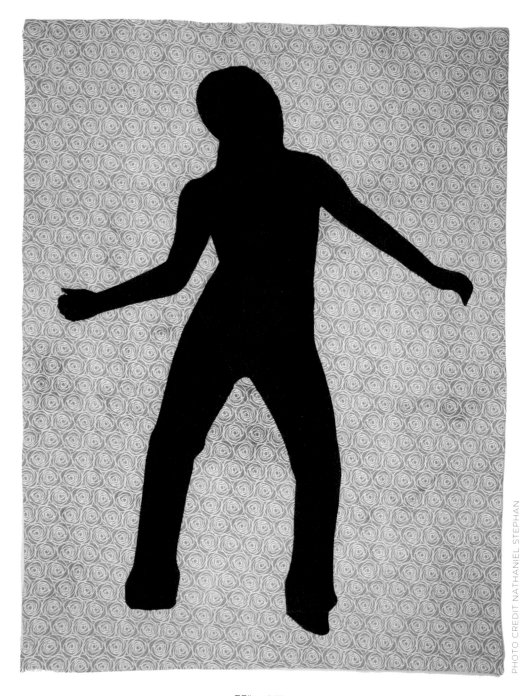

33" x 44"

KAREN S. MUSGRAVE

PHOTO CREDIT NATHANIEL STEPHAN

The message I received growing up was that I was less because I was female and that the misogynist acts against me were my fault. Naively I thought the world had changed, because mine did. Unfortunately, this is clearly not true. I am frustrated at how women are continually silenced and how this response, in turn, manages to protect toxic unacceptable behavior. I am saddened to see how much work women still have to do to be considered equal. Michelle Obama said it so well: "Strong men, men who are truly role models, don't need to put women down to make themselves feel powerful." Isn't it time for misogyny in all its forms to end?

WORK IN PROGRESS

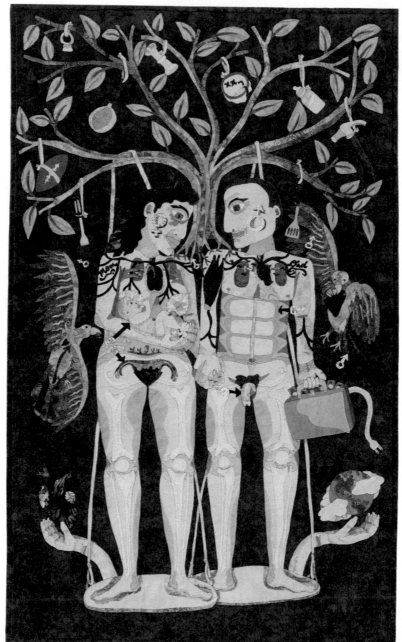

36" x 60"

KATHY NIDA

This concept of gender equality – there are days when it's like a dream, something I woke up with, foggy-edged, but possible. Then I go out into the real world and the expectations others have because I am female, daughter, mother, sister, wife, girlfriend … they clash incredibly with that dream, where there are no assumptions of who or what I will be, or what my son or daughter will be … there isn't anything I HAVE to do because I was born with two X chromosomes and you were born with one. We aren't there yet; it's a work in progress.

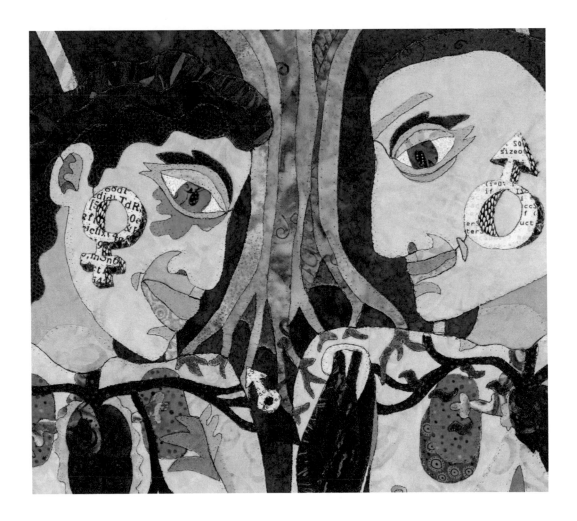

ABSOLUTELY NOTHING

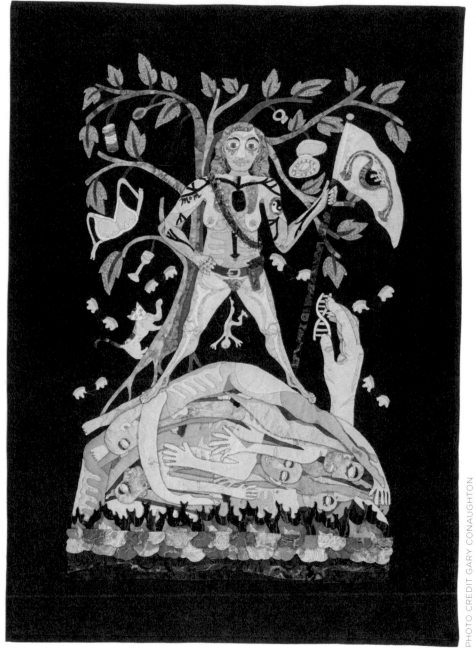

36" x 50"

KATHY NIDA

From birth, woman is at war with society, with the pink she's supposed to wear, with her period and all its implications, with her rights to her uterus and all its products, with her right to wear clothing and not be assaulted … for that matter, to not be assaulted, no matter what. We achieve an uneasy balance with the war in our bodies, with the hormonal surges and bloody flow, a balance that is regularly damaged by puberty, pregnancy, and menopause. We are at war in our jobs, in the grocery store, with our bras, in our home lives, in the laundry room, with our stretch marks, in the boardroom, in line at the DMV, filling our tanks with gas. Even choosing our last names… there's another battle.

She stands strong. War … what is it good for? Absolutely nothing. Here's to a society without all that conflict, to equality.

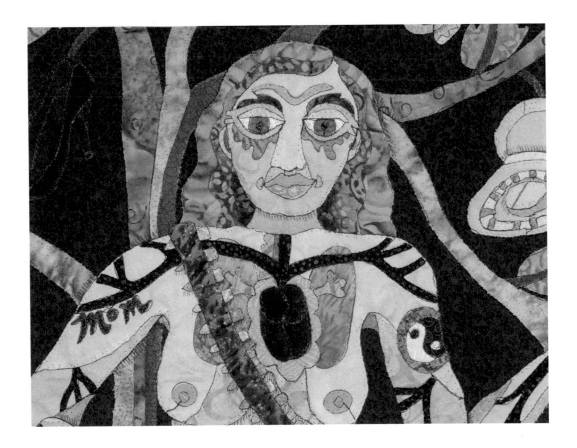

CAPITOL GUNS

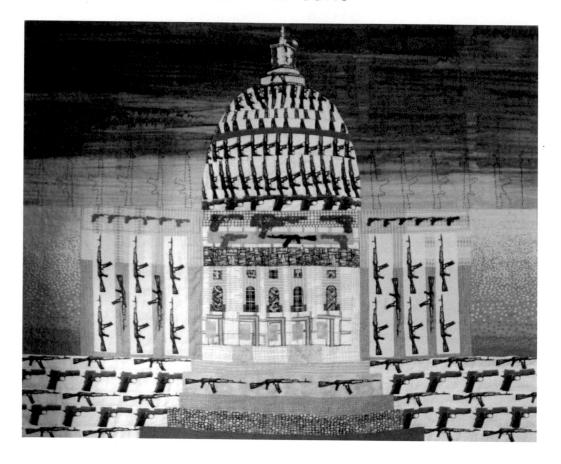

45" x 38"

ELLEN F. NOVEMBER

There was a mass shooting at UC Santa Barbara in 2015. A local son was shot and killed during this event. This pushed me to join Moms Demand Action, a program of Everytown for Gun Safety, the largest gun violence prevention advocacy organization in the country, with more than 3 million grassroots supporters. I do not want to see another senseless death due to gun violence.

I was greatly disappointed that neither the House or Senate would bring the topic of gun violence advocacy to the floor for a discussion. Moms Demand Action is working to demand action from legislators, state and federal; companies; and educational institutions to establish common-sense gun reforms.

My art piece, "Capitol Guns," is my statement on the disregard for addressing the gun violence epidemic in the United States. Perhaps the NRA lobbyists own the House and Senate, which prevents our elected officials from acting to save lives.

Even after the tragic shooting of one of their own, Gabby Gifford, there was no action taken. Even after the devastating mass shooting at Sandy Hook Elementary School, no action was taken. And more recently,

Bernardino and the 49 lives lost in Orlando.

I'm looking to you to save lives by supporting common-sense measures like background checks to curb gun violence. We need to work to prevent even one more senseless death. Change the Capitol Building from a "House of Guns" to a "House of Reason."

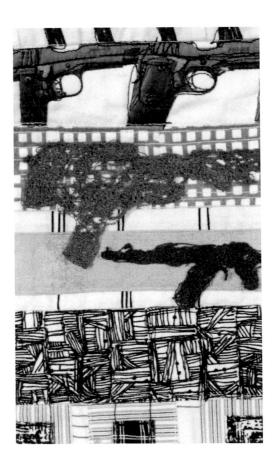

SEEKING REFUGE

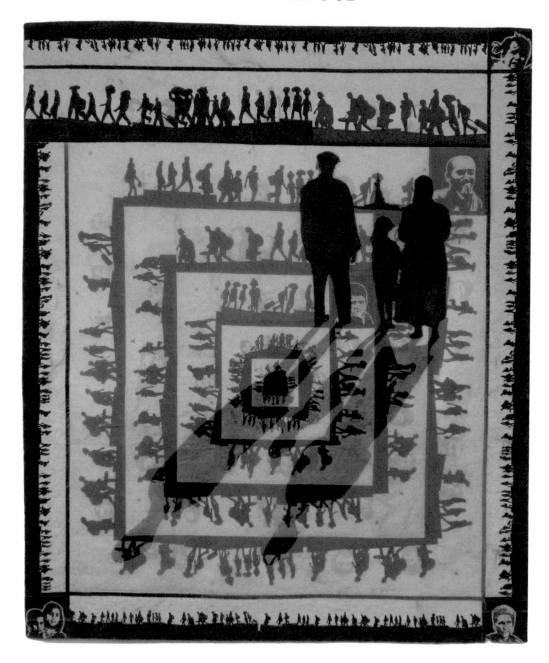

35" x 41"

DO PALMA

This is my response to the ongoing refugee crisis around the world. In addition to paying tribute to the suffering of so many, I am also frustrated at my own country's refusal to settle refugees, in spite of our capability to do so.

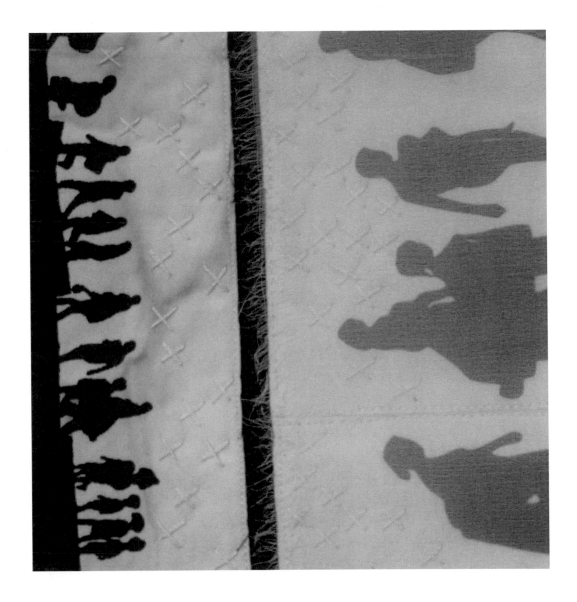

NEVERTHELESS, THEY PERSISTED

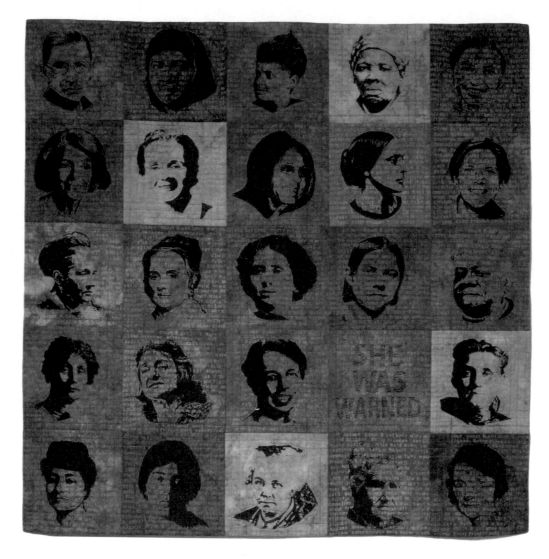

34" x 34"

DO PALMA

This is my response to Mitch McConnell's decision to block Elizabeth Warren from testifying at the Senate confirmation hearing for Attorney General Jeff Sessions. Warren was reading a letter from Coretta Scott King that was critical of Mr. Sessions. McConnell stated, "She was warned. She was given an explanation. Nevertheless, she persisted." Later, other (male) senators read the same letter into the record.

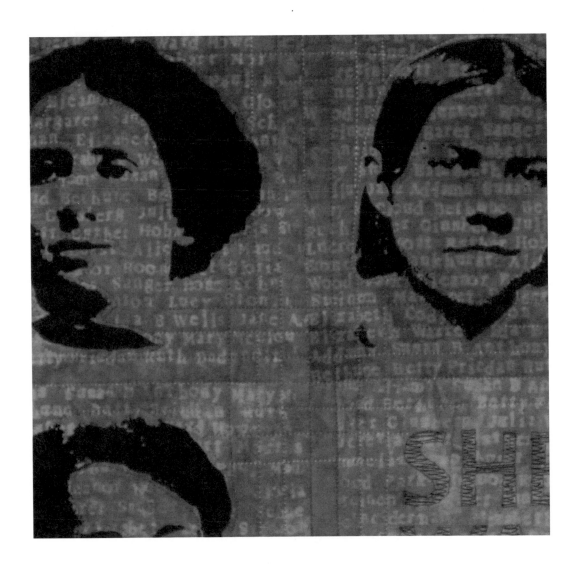

THERE'S SOMETHING BETWEEN US

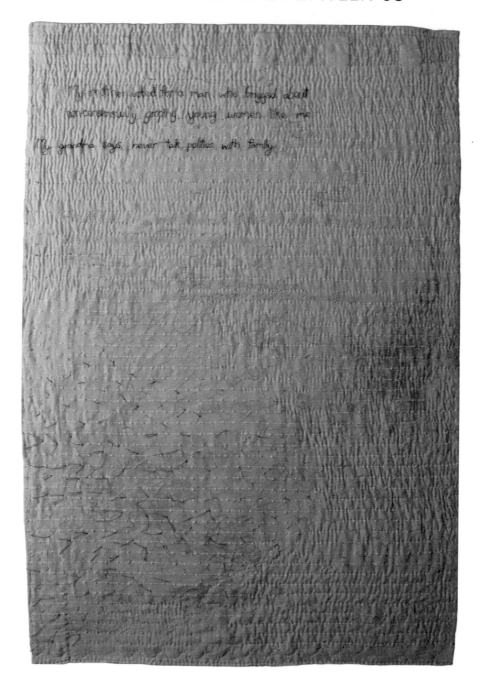

38" x 56"

HEIDI A. PARKES

In recent years, my mother's politics have shifted, and she has made it clear that she doesn't want to discuss her politics with my brother or me. This election has been deeply troubling, and has raised ethical questions that I cannot shrug off as 'just politics.' It has created a tangible discomfort in our relationship.

This quilt is an attempt to communicate my heartache over this political divide, as expressed in words, artifacts, and abstract mark making. There are seven phrases embroidered and visible with varying levels of ease, articulating a combination of facts and questions. The quilt is made with a curtain that my mom helped me buy, and that she hemmed for me by hand. These stitches are present in testament to my mother's deep love for me. They remind me of the countless ways that my mother continues to show her love and care for me. There are two curtains layered in the quilt, and the object, 'Curtain,' has many powerfully evocative meanings, in reference to seeing clearly, division of public and private, separation, 'blinds,' concealment, privacy, etc. … Employing the techniques of layering, hand quilting, and tying knots, the same threads that were used for language now express visually many of the feelings I am unable to articulate in words to my mother and in embroidered text on this quilt. I feel tied up in knots over this misalignment of values and truths; unraveling, invisible, transparent, snarled, confused…

This work was made with the hope that spending time meditatively and in connection with these objects from my mother – that I could find a way back to loving language with her, while simultaneously holding true to and reaffirming my values as an American. It was also made with an awareness that this divide is echoed in many families across the country.

GET WOKE

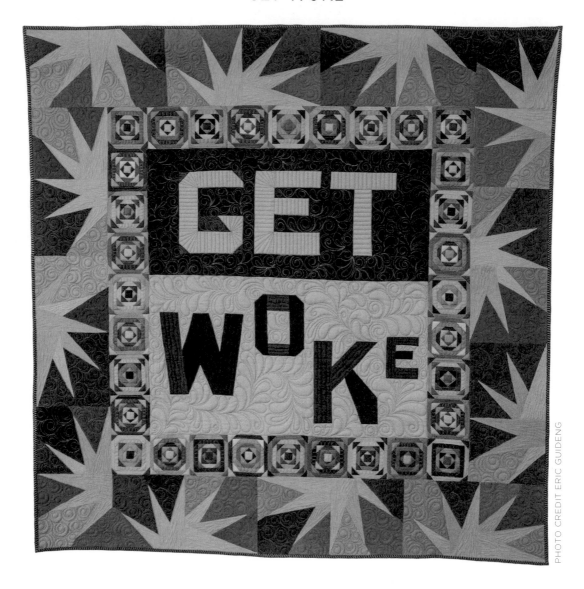

46" x 47"

JULIE PARRISH

The Oxford Dictionaries shortlisted the word "woke" for the 2016 word of the year. It has been traced back from the 1960s to now as American slang for "informed, up-to-date." The term "stay woke" has been used by Black Lives Matter to urge awareness of issues that are a question of privilege and oppression. Jeffrey Beauregard Sessions, attorney general of the United States, has called a white civil rights lawyer a "disgrace to his race," and the NAACP "un-American." With the confirmation of an avowed racist and investor in private prisons as chief law enforcement officer of our nation, there is urgency for the American public to be engaged and resist against this brutal, corrupt regime and the realities that people of color face. There has never been a more critical time to "get woke." Quilted by Vicki Ruebel

WE WALK TOGETHER IN SEARCH OF LIBERTY

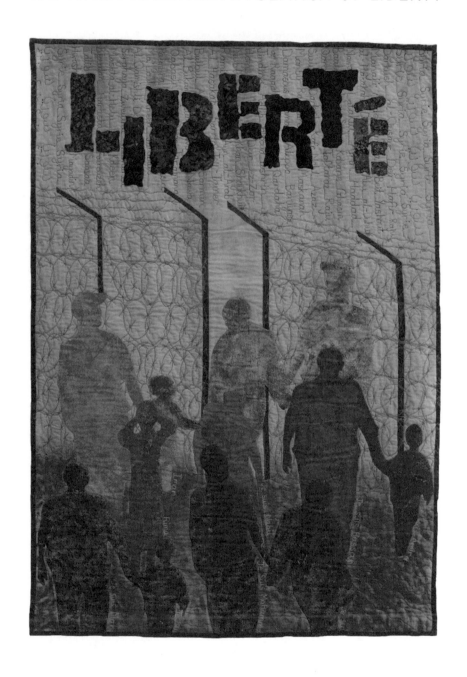

34" x 50"

CLAIRE PASSMORE

March 15, 2011, Syria: popular protests began in many parts of the country, expressing discontent toward the government of Bashar al-Assad. His government responded with brutal force. Since then a great number of alleged human rights violations have occurred, initiated by many groups. Mass executions, chemical weapons, thermobaric weapons and cluster bombs have all been used on the population. It is estimated that around half a million people have been killed. Those who were able have fled the country by car, train plane, and boat and on foot, walking together. Human traffickers have made a fortune. Politicians have "made their name." By March 2017 the number of refugees that have fled Syria exceeded 5 million and more than 6 million others are internally displaced. More than 50% of the refugees are children. But this is not about numbers. It is about people.

This conflict has taken many complex twists and turns, and the horrors the refugees have experienced are unimaginable to those of us who live safe lives far from this place. Many people have welcomed the refugees. Many people have not. To them I say this…

Put yourself in their shoes for just a moment. Imagine packing a single bag, gathering what is left of your family together, and closing the door to your home for the last time. You have left your job, your car, your possessions. Everything you ever worked for. There is no longer any food, no water, no shelter. It has all been destroyed. So you start to walk in the hope that you can be somewhere safe. Where? Who knows? But anywhere would be better than here.

In the years to come, when those children are grown into adults, what will they think of us, and how will they react to us – the rest of the world? Will they say, "It's OK – you did your best. There were a lot of us and you had your lives to lead. We understand that your country was 'full' and that you were broke and had no more money to spend on anyone else." Or will they be furious at the way they were treated in their hour of desperate need? Herded into camps, hounded and chased out of towns, cities and countries, left to fend for themselves, banned from entry…
And what will happen then?

LIBERTY ASSAULTED

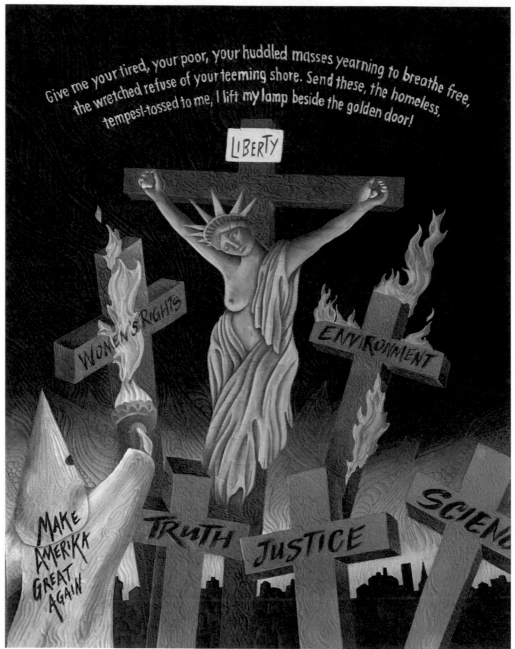

26" x 34"

JUDY COATES PEREZ

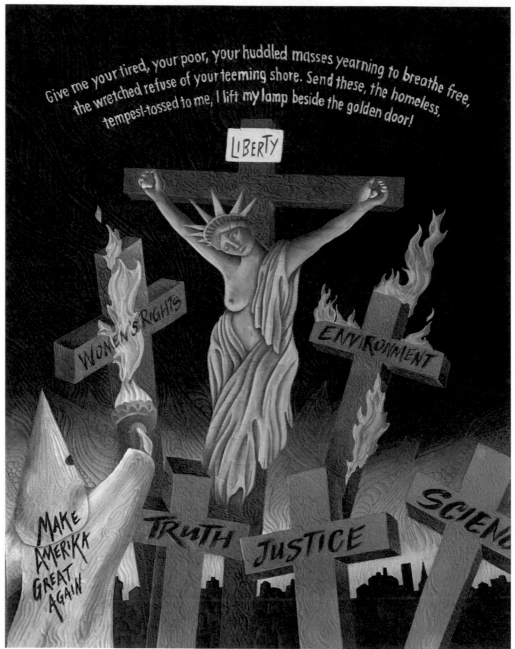PHOTO CREDIT INDIGO PEREZ

I feel very strongly that racism, calculated deception and dishonesty won the presidency for Trump. His administration is an assault on people of color, women, the poor, education, science, facts, the environment and the personal freedoms and rights that made America the land of the free.

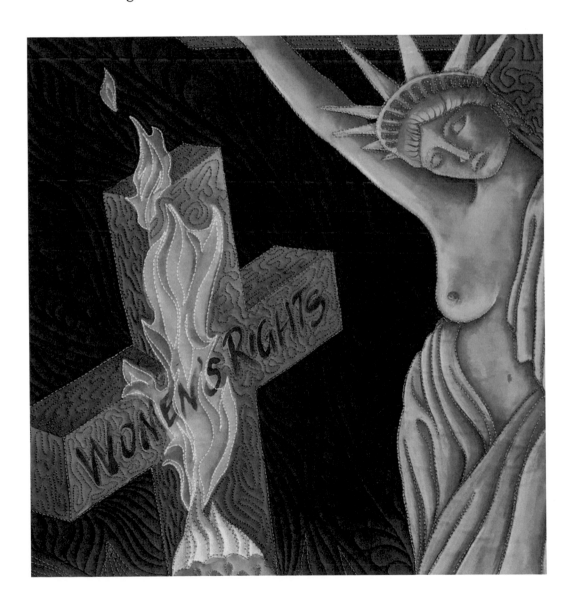

UNPLUGGED

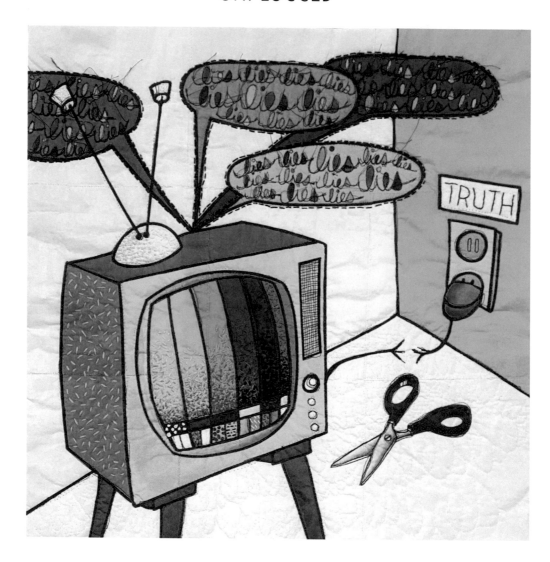

20" x 20"

KELLI N. PERKINS

When creating, I am drawn to the intersection where the common, everyday object meets an unexpected element. Often, this encounter reveals inconsistencies in how we relate to one another. The same hands that bake a pie can build a bomb. Malevolence is most disturbing when it's woven into the mundane.

In acceptance that kindness and corruption co-exist, my work revels in bright colors and frenetic stitching, expressing an unfailing sense of optimism. Whether through genetics or environment, I've inherited an unshakeable feeling that everything will be all right.

In "Unplugged" we see that the media has abandoned truth for the far more colorful and enticing lies, lies and more lies. The untruths are so mesmerizing that we can't look away, even as the sign-off test pattern fills the screen. The lies, though bright and cheerful, are tangled up and knotted, causing confusion. We don't know where one ends and another begins. We have come unplugged from reality, though the scissors-wielding agent of our doom has not been named. We must learn who benefits from the perpetuation of alternative facts in order to trace the roots of our problem and restore our future. It may be time for us to turn off the screen and talk to each other.

WHAT DOES AN AMERICAN LOOK LIKE?

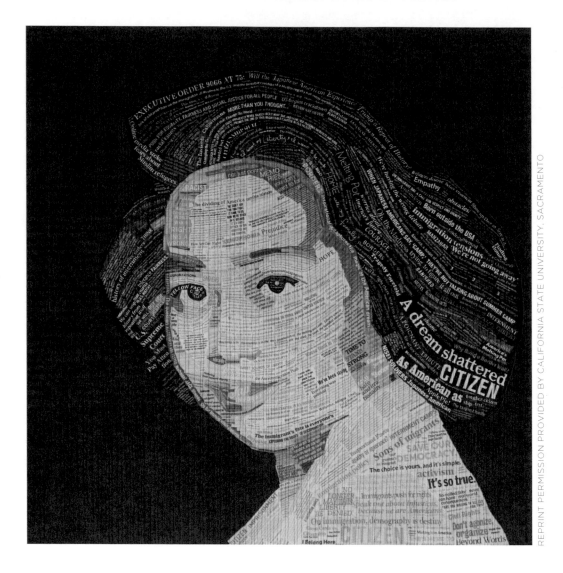

34" x 35"

THE PIXELADIES: DEB CASHATT AND KRIS SAZAKI

In 1942, President Roosevelt signed Executive Order 9066, which resulted in the incarceration of Mitsuye Endo and 120,000 other Americans of Japanese ancestry. She became a plaintiff in a lawsuit filed by the ACLU to strike down her incarceration as unconstitutional. Despite governmental offers of an early release, Endo remained in camp in order for the case to make it to the Supreme Court. Her victory led to the release of the prisoners in 1945. Fast forward to 2017 when we have witnessed President Trump sign first Executive Order 13769 and then Executive Order 13780, "Protecting the Nation from Foreign Terrorist Entry into the United States." Both orders have been stopped by lower courts, so this "Muslim Ban" has yet to be implemented. This case is making its way to the Supreme Court.

These executive orders may be separated by 75 years but rely on the same fears of "the enemy." That is why we pose the question, "What does an American look like?" Mitsuye Endo was an American. She was born in Sacramento, California, graduated from high school, and went to work for the California state government until she was fired from her job and incarcerated. So as you look around the room today, can you tell us what an American looks like?

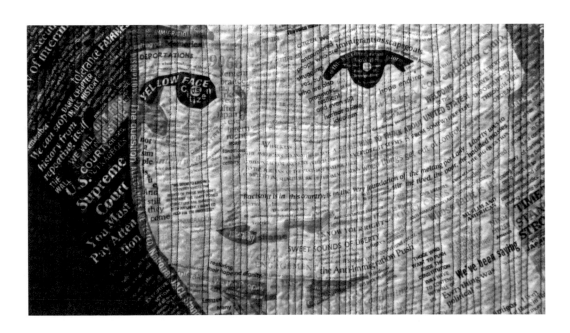

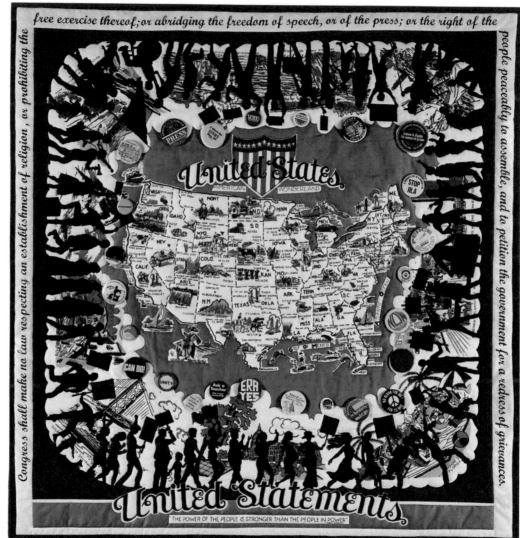

47" x 50"

SUSAN V. POLANSKY

My mother would have envisioned the use of her tablecloth as an invitation for folks to gather round for pleasant chat over a meal, perhaps inspired by the scenic vistas of "America's Wonderland." Her preference to avoid politics at the table led to some bland, polite discourse, as she realized what holy hell could be unleashed if people spoke their minds. Political discussion brings out the passion of our true convictions, unifying and dividing not only those we sit next to, but the country at large.

Debate over today's civil climate rages and I find myself strongly opinionated, desirous to join the resistance to objectional stances. Distilling my feelings leaves not the bitter core I expected, but a positive, hopeful nugget instead: an appreciation that the wonder of our land is that we can freely dissent. The First Amendment to the United States Constitution guarantees our rights of expression, a privilege envied around the world. Spurring political protest in his own country, Egyptian Wael Ghonim said, "The power of the people is much stronger than the people in power."

I join the ranks of marchers, past and present, who stand up for their causes. My voice alone may be small, but as part of a united statement, it is a force to be reckoned with. I hear the sound of resistance swelling to an undeniable volume, and hungrily anticipate change brought about by activism.

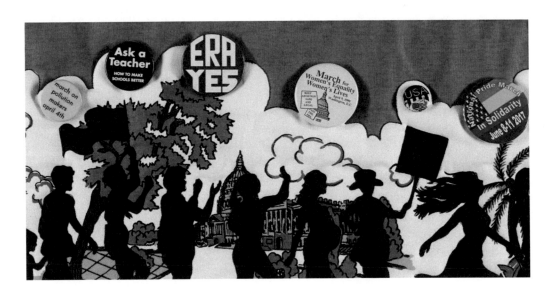

CHASM

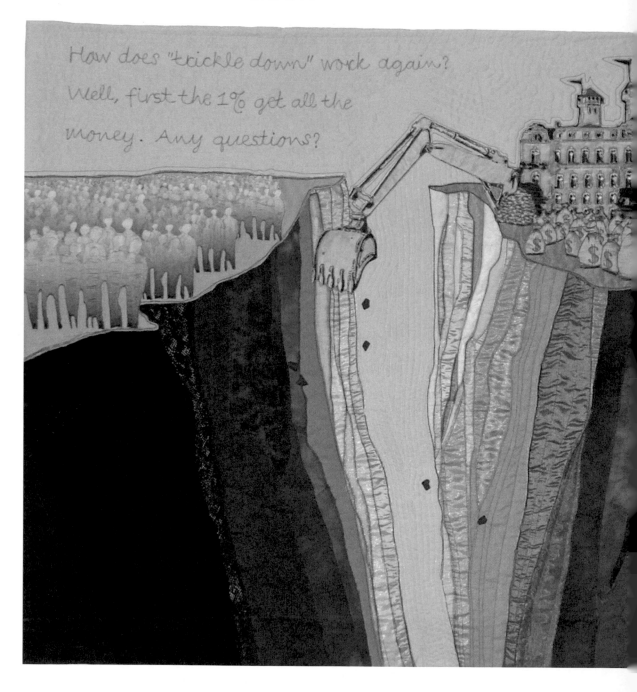

44" x 35"

SANDRA POTEET

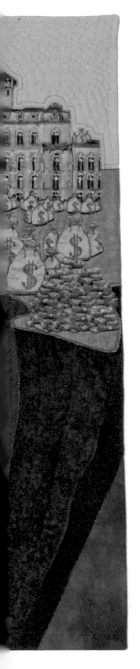

The gap between rich and poor continues to grow, and the middle class – essential to a government for the people by the people – is shrinking rapidly. We can continue with policies that favor the privileged, or not.

DON'T SHOOT
(UNTIL YOU SEE THE WHITES OF THEIR EYES)

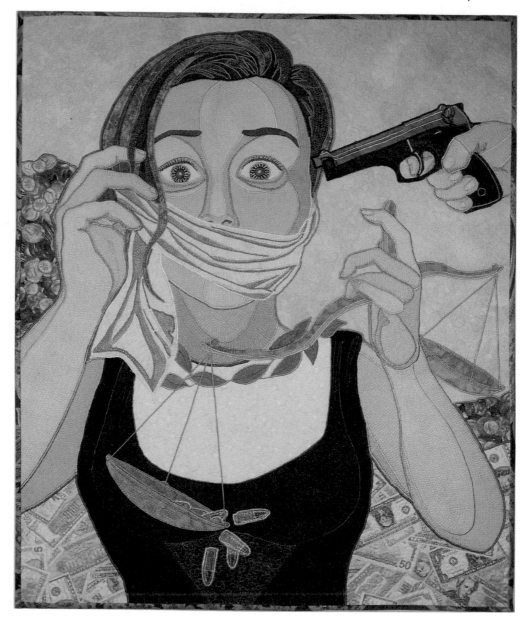

23" x 28"

SHEILA H. RIESS

After the Sandy Hook Elementary School shooting, which left 20 first graders and 6 adults dead, President Obama brought a measure to Congress that sought to block some people with severe mental health problems from buying guns. Mr. Obama wanted to bring about tougher gun control measures but was blocked by Republicans and Democrats alike. When asked about his regrets upon leaving the White House, he replied that his biggest regret was not being able to do more for the victims of Sandy Hook.

Within 60 days of being in the White House, President Trump signed a bill revoking the Obama-era regulation of gun checks for people with mental illness. Gun control advocates fear this is just the first in a series of gun control rollbacks from the Trump administration, since gun lobbyists such as the National Rifle Association applauded Trump's action. The NRA pushes hard for no gun control legislation and would like to have more Americans purchasing guns with ease.

My artwork represents how unbalanced the justice system is when dealing with the issue of gun control. In my quilt I have Lady Justice tearing off her blindfold (the symbol of impartiality in matters of justice and law) only to have it cover her mouth and make her unable to speak out against horrors she keeps witnessing due to the lack of gun control in America. Her scales of justice are so unbalanced and weighed heavily with bullets (my symbol for the ever-present NRA). The money in the background represents the big business of the gun lobbyists who use their money and influence to make sure no gun control legislation ever passes in Congress, or, as in the case of President Trump, is repealed immediately. The material used for the binding (which reminded me of men's ties) is representative of all the politicians and lobbyists who circle around the justice system and squeeze anyone who tries to pass any gun control laws.

A DAY TO REMEMBER

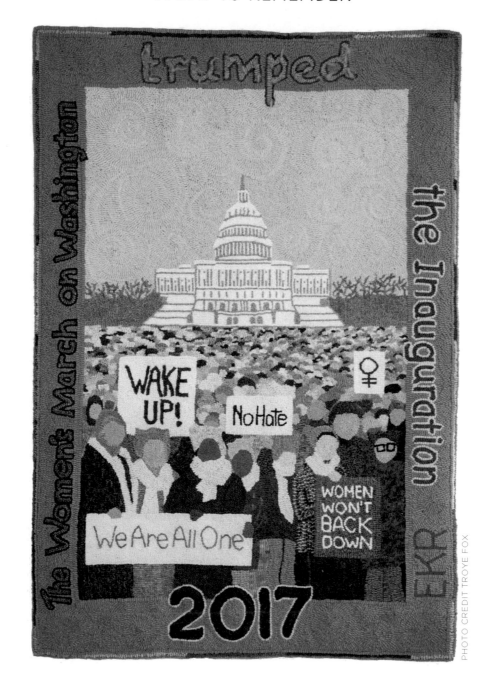

36" x 52"

EMILY K. ROBERTSON

As soon as I knew there was going to be a march, I knew I needed to be there and be a part of it. The day was one of the most memorable days of my life. We were more than 500,000 in number and all of one accord, to protest the threats against our rights as women and as citizens of this country. I wanted to portray the magnitude of the crowd, the solemnity of the issues, and the congeniality of the crowd.

ROE V. WADE MUST STAND

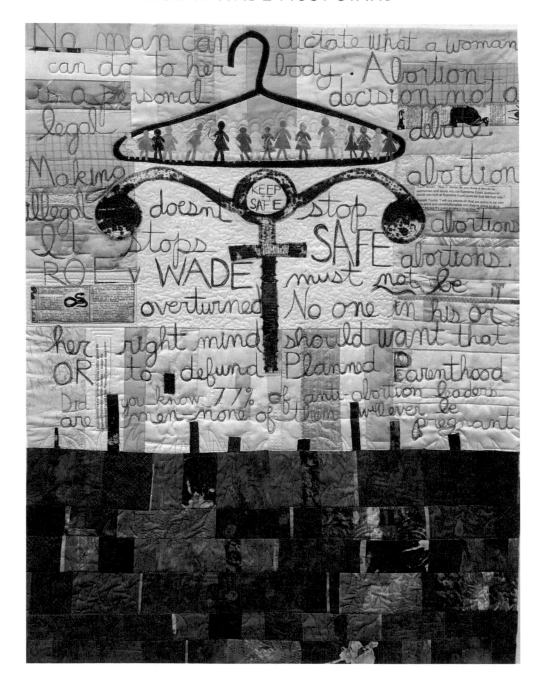

34" x 44"

CYNDY M. RYMER

My anger about Roe v. Wade possibly being overturned inspired this quilt. Women should have complete freedom over what they with their bodies. Abortions will continue to happen, and the main point is to make them safe. Making this quilt was a way to express my disgust with the current administration.

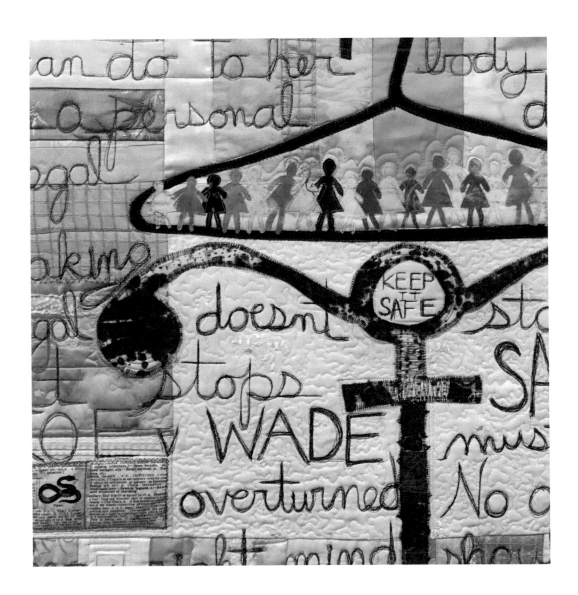

LEARN TO QUESTION – LEARN TO LEAD

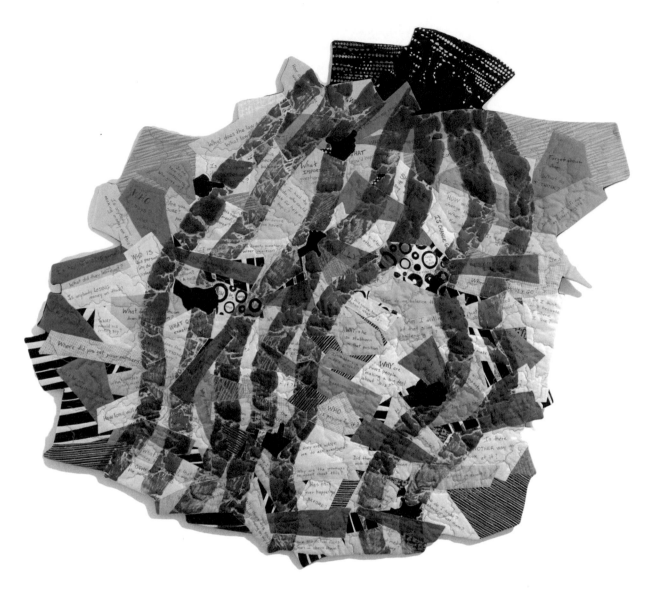

44" x 39"

CANDACE HACKETT SHIVELY

Our kids – and many adults – do not know how to ask the serious questions. They lack the deep understanding of how our nation works and passion to assume its leadership. As our schools have focused on "tested content" for more than a decade, our elementary and middle schools have reduced attention on social studies/history/civics – subjects not included in the high-stakes tests. The foundations of history and citizenship in younger years form a basis for young adults to seek nuance and evidence in their decision-making. Many Americans have never learned to question and reach this level of nuanced participation. In a dangerous confluence, the early 21st century has seen the media, the Internet, and our "leaders" blur our government beyond recognition while pretending that everything is black and white. Today we ALL need to question: question the media, question the tweets of our "leaders," question our devices, question our sources, question our own friends and family – even question ourselves – to be the citizens and leaders necessary for our nation's survival.

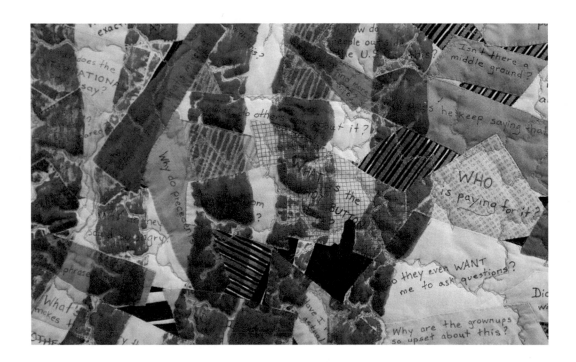

SPEAK UP, SPEAK OUT

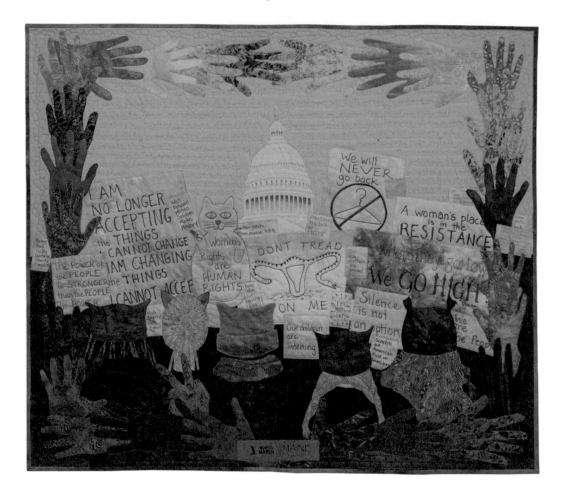

48" x 41"

SARAH ANN SMITH

During the 2016 election debates in autumn, I became angry that the Republican kept saying, "Make America great again," meaning he felt our nation wasn't great. I kept shouting back at the TV, "America is already great, let's make it even better." I began sketching a protest quilt to be surrounded by hands, with words and phrases.

Fast forward to Jan. 21, 2017, when I traveled from Maine to D.C. for the Women's March on Washington. On the way down, I asked riders on our charter bus to trace their hands for me to use in an art quilt, and every hand that was traced is on the quilt. At the march, I finally realized what would be in the center: us, the people at the march, democracy made manifest. I took a zillion photos and selected phrases and signs to use. Though the Women's March image has become iconic and ubiquitous, it is my personal story, too (that's me on the far right). In the background, I stitched the Preamble to the U.S. Constitution, the four freedoms in the First Amendment, and more phrases. I have never been overtly political… until now. As a former U.S. Foreign Service officer (diplomat) and federal employee, we were not allowed to participate in politics. Well those days are over!

It is time to Speak UP, Speak OUT, and PARTICIPATE in our democracy, and yes, I am shouting. I am starting by volunteering for my tiny, rural town of Hope, Maine. What will you do? How will you speak out to defend the progress of the past 75 years against the current onslaught? We made history on Jan. 21 at the peaceful and outspoken Women's March on Washington. The individuals of our nation are what make our government and our democracy. Work together! PARTICIPATE! Especially, write to your elected representatives at every level from town to national, and VOTE. We will not be silenced. WE ARE the People!

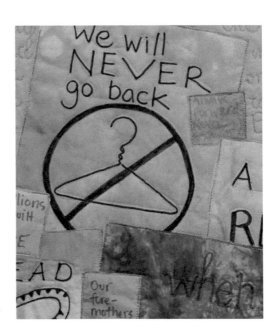

PATRIOTISM

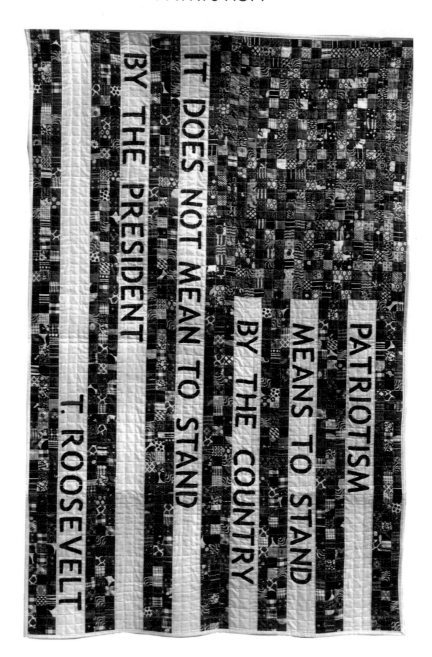

The quilt contains the text: "PATRIOTISM MEANS TO STAND BY THE COUNTRY. IT DOES NOT MEAN TO STAND BY THE PRESIDENT. T. ROOSEVELT"

34" x 54"

AMY D. SULLIVAN

Patriotism has always been very important to me; I love my country and I am heartbroken it is so divided. Seeing the gap between Republicans and Democrats widen, I wanted to remind my friends and neighbors that we are all Americans. I wanted to state my love of the country and the need for me to resist.

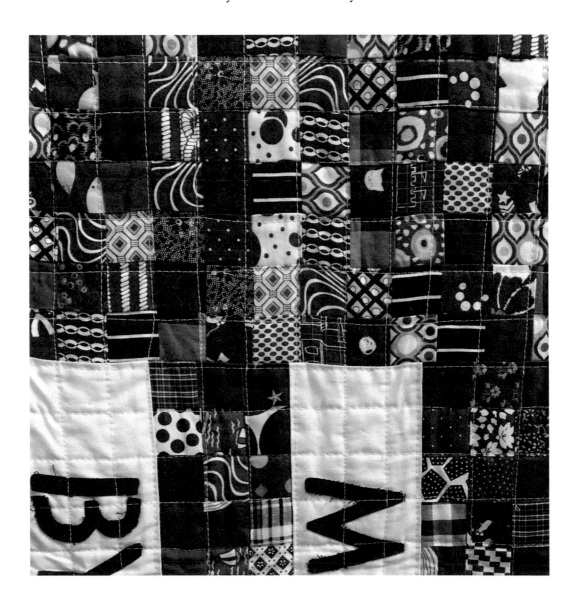

TOXIC MASCULINITY MUST END

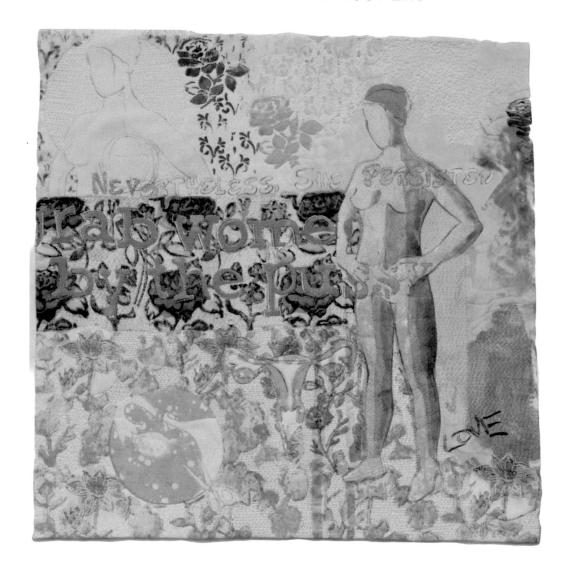

22" x 22"

MELANIE TESTA

Toxic masculinity describes a socially constructed role that values domination and control of others above emotional connection, compassion, intellectual and fair exchange. Toxic masculinity is an expression of patriarchy and limits all who come in contact with it, especially men. Toxic masculinity is the fetid, all consuming, cancer of our time.

Unfortunately, women often pay the price for these unquestioned behaviors. We have internalized the fear of being raped to such a degree that we blame ourselves when it happens. We are reviled as whores as quickly as we are praised for our beauty, even when it is our intellect we value most. We bring home less money for similar jobs held by our male counterparts. Our bodies face highly regulated access to health care; we are charged more for haircuts, clothing and personal hygiene products and more.

When I heard the tape of the "man" who is now president of the United States of America say, "Grab 'em by the pussy. You can do anything," I felt rage. As there is no female equivalency to emasculation, I use breast cancer as a metaphor in its place. Breast cancer removes our breasts, cuts our ovaries out of us, distills us to the very essence of our beings, but nevertheless, we persist.

It is time to dismantle these unworkable storylines and create space for a broader more diverse equality.

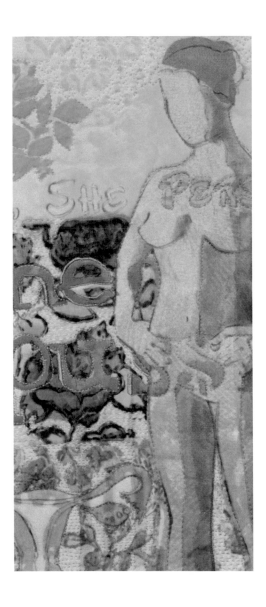

WOMEN'S RALLY, GREENVILLE, SC. JANUARY 21, 2017

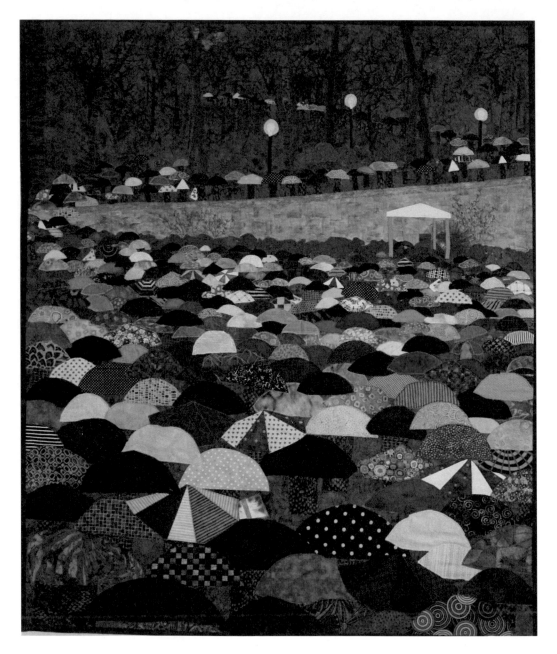

36" x 43"

DENNY (DENISE) C. WEBSTER

As a relatively new transplant to this deeply Red State, I feared I might be the only one to join the local "march" to demonstrate Resistance to the beginning of the Trump administration. The clouds gave way to heavy rain, but my heart lifted at the sight of all of the "hidden" resisters who poured into Falls Park that day. After more than 50 years of work related to the Women's Movement, I remembered I am not alone.

FILL 1,000 SEATS

44" x 53"

JULIE WEINSTEIN & FRAN SHARP

Shortly after the presidential election in 2016, we read that Democrats lost more than 1,000 legislative seats between 2008 and 2016: 11 governorships, 13 senate seats, 69 house seats, and 913 state legislative seats. We've since learned that those numbers are slightly exaggerated and that every president's party loses seats during the term. But we were shocked at the numbers and the implications of these losses. We also realized that getting Democrats elected at all levels would be a positive focus for our anger, fear and disgust at the new administration. Not instead of demonstrations, letters, petitions and phone calls, but in addition to those actions.

This quilt focuses on the idea that we need to fill 1,000 legislative seats with progressive Democrats at every level of government to restore decency and sanity to the nation. There may not be exactly 1,000 chairs on the quilt, but we came close to that number in the custom-designed and printed wallpaper fabric. Our ideas and hopes about the current political and electoral situation make up the words on the custom-designed and printed floor fabric.

Please vote, participate, and work to fill legislative seats. It will take all of us to get this done. It will take time, but we can do it.

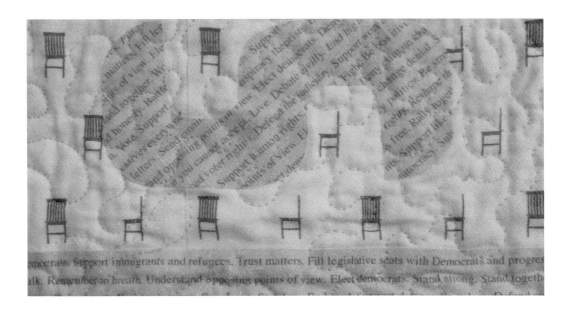

TEARS OF THE GRANDFATHERS

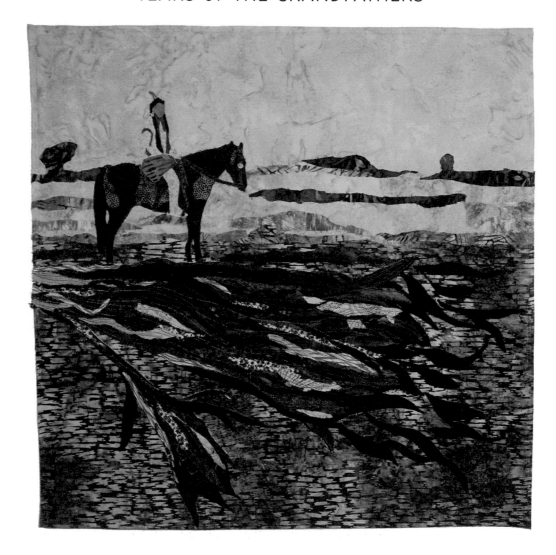

22" x 22"

LENI L. WIENER

Sustained for generations by clear waters and abundant resources, the Lakota and their neighboring tribes lived in respect of the land. Now the Dakota Access Pipeline endangers these crystal waters and the lives of the Standing Rock Lakota; in the path of potential destruction also lie their ancient burial grounds, compromising not just their future, but the preservation of their past.

After so many broken promises and broken treaties many have raised their voices this time in protest, to protect and preserve that which sustains us all. And yet the pipeline, in the guise of progress, threatens everyone in its path. Perhaps it will never leak, perhaps it will. Who can know?

This is not about jobs, it is not about profits, it is about the right to stand up and say no; no to intimidation, no to environmental contamination, no to the loss of self-determination and yes to freedom of choice. Oil in the pipe will flow like the tears of the grandfathers. Mni Wiconi. Water is life.

RESIST

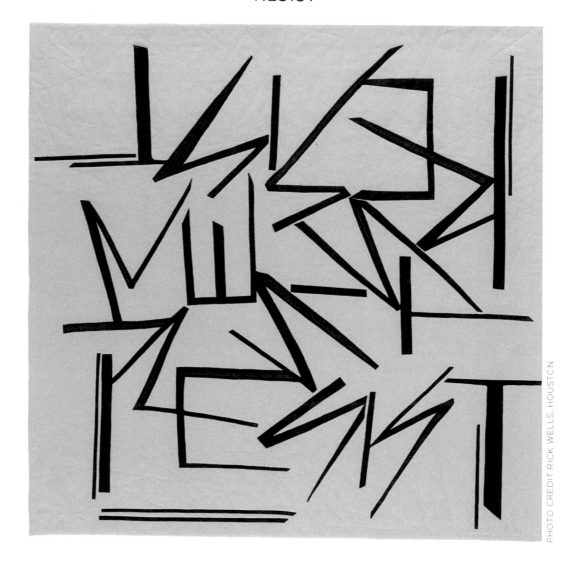

36" x 35"

HOPE WILMARTH

2017 has seen protest rallies on the rise in all corners of the world. Resistance with its sharp and jagged edges has demanded attention. Resistance is being noted, slowly and surely.

PRIVILEGED TIMES

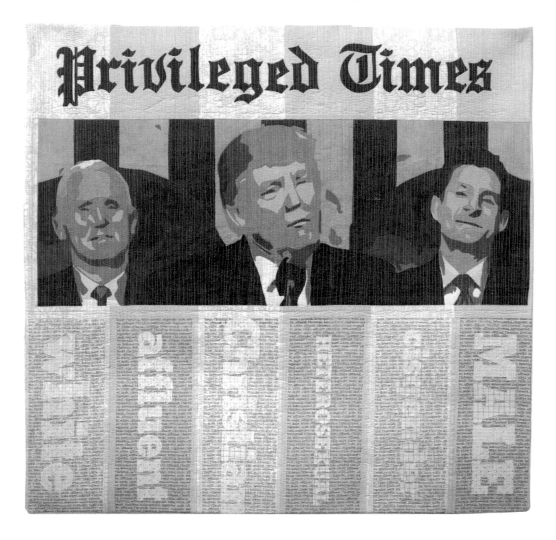

29" x 28"

MARTHA WOLFE

"Privilege is when you think something is not a problem because it's not a problem to you personally." – David Gaider

I've thought a lot about privilege since the new administration took office. Throughout our lives, we benefit from a variety of privileges we have nothing to do with obtaining and make assumptions about the world based on that experience. With the best intentions, we rally for equality without truly feeling the anxious existence "others" live on a daily basis. Watching how privilege is being used to cultivate prejudice and discrimination, subtle and blatant, makes these issues problems for everyone.

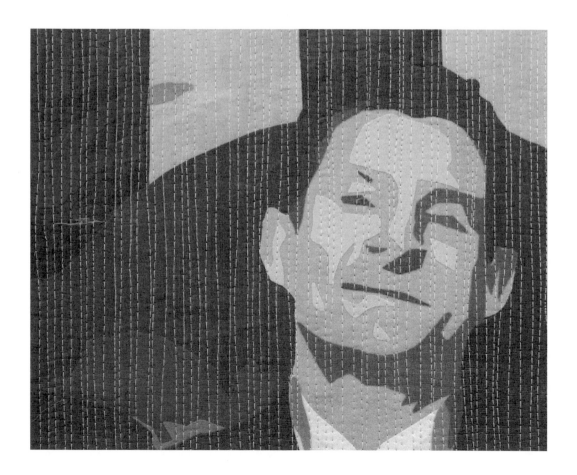

UNBEARABLY BAD BUSINESS

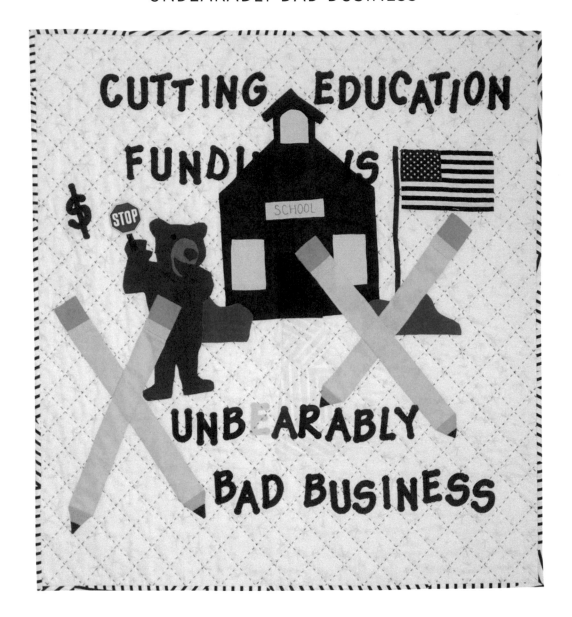

31" X 33"

VICTORIA FINDLAY WOLFE

This has all seemed so childish. Bullies, bad decisions, incoherent statements, grizzlies, grabbing and more... Ultimately, messing with our future by cutting our children's education seems to me the most shortsightedness ever by our current government.. Has history not taught us anything? Invest in our future! Keep our children educated and alive. Feed Education and keep guns out of children's hands.

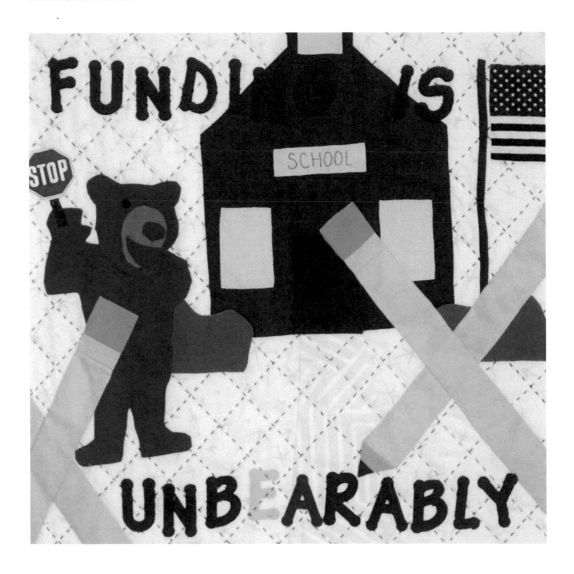

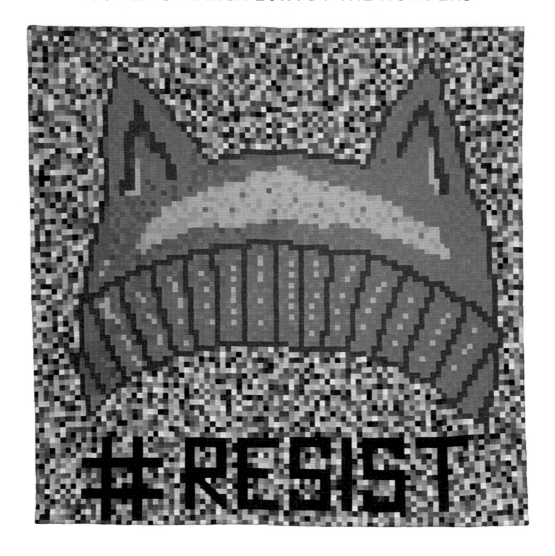

48" x 48"

KATHY YORK

This quilt was made to honor the 3 million women who marched globally the day after President Trump was inaugurated. I wanted to give the viewer a feeling for just how big 3 million is. Each little square is ½ inch and represents 325 people. That is equivalent to a large jet airplane filled with people. So imagine a full airplane for each one of these tiny squares! It is A LOT of people, all marching to protect the rights of women!

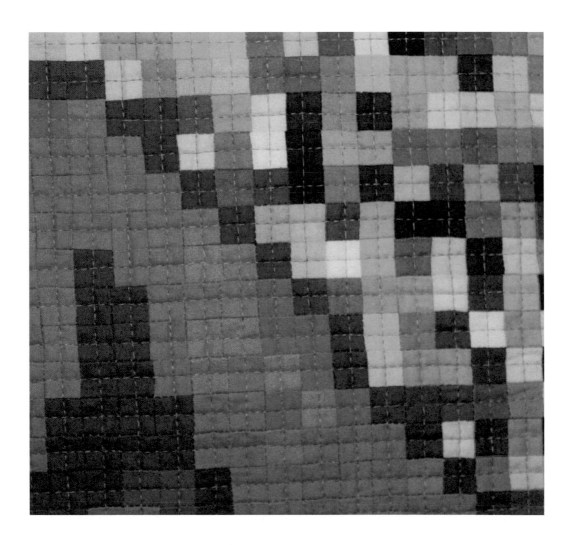

WEBSITES

DAWN ALLEN: www.dawnallen.net
MEL BEACH: www.melbeachquilts.com
ALICE BEASLEY: www.alicebeasley.com
SUSAN BIANCHI: www.suebianchi.com
SUE BLEIWEISS: www.suebleiweiss.com
BARBARA BRANDEL: www.barbarabrandelartist.com
TANYA BROWN: www.tanyabrown.org
SUSAN BRUBAKER KNAPP: www.bluemoonriver.com
SANDRA BRUCE: www.sandrabruce.com
BETTY BUSBY: www.bbusbyarts.com
JUDY COATES PEREZ: www.judycoatesperez.com
MARYTE COLLARD: www.marytequilts.eu
SHANNON CONLEY: www.shannonconleyartquilts.com
PHYLLIS CULLEN: www.phylliscullenartstudio.com
AMY DAME: www.amydame.ca
TRICIA DECK: www.triciadeck.com
VICTORIA FINDLAY WOLFE: www.vfwquilts.com
JAMIE FINGAL: www.JamieFingalDesigns.com
LINDA FRIEDMAN: www.indasartquilts.blogspot.com
KERRI GREEN: www.kerrigreenartquilts.com
NEROLI HENDERSON: www.eiloren.com.au
SYLVIA HERNANDEZ: www.BrooklynQuiltGirl.com
AUDREY HYVONEN: www.BigTopQuilts.com
LESLIE TUCKER JENISON: www.leslietuckerjenison.com
SARA KELLY: www.sarakellyartquilts.blogspot.com
LYRIC MONTGOMERY KINARD: www.lyrickinard.com
KRISTIN LA FLAMME: www.kristinlaflamme.com
ANN LEE: www.FriendsFabricArt.com

JESSICA LEVITT: www.juicy-bits.typepad.com

KATHERINE MCCLELLAND: www.marsupicool.com

SARA MIKA: www.mockpiestudio.com

GILLIAN MOSS: www.mossartquilts.com

KAREN MUSGRAVE: www.connectionsbykaren.blogspot.com

KATHY NIDA: www.kathynida.com

ELLEN NOVEMBER: www.ellennovember.com

DO PALMA: www.dopalma.com

HEIDI PARKES: www.heidiparkes.com

CLAIRE PASSMORE: www.clairepassmore.com

KELLI PERKINS: www.kellininaperkins.blogspot.com

THE PIXELADIES: www.pixeladies.com

SUSAN POLANSKY: www.susanpolansky.com

SANDRA POTEET: www.sandrapoteet.com

EMILY ROBERTSON: www.emilykrobertson.com

CANDACE HACKETT SHIVELY: www.makinloud.wordpress.com

SARAH ANN SMITH: www.SarahAnnSmith.com

AMY SULLIVAN: www.amakerofstuff.com

MELANIE TESTA: www.melanietesta.com

LESLIE TUCKER JENISON: www.leslietuckerjenison.com

DENNY (DENISE) WEBSTER: www.dennywebster.com

JULIE WEINSTEIN: www.julieweinsteindesign.blogspot.com

LENI WIENER: www.leniwiener.com

HOPE WILMARTH: www.hopewilmarth.com

MARTHA WOLFE: www.marthawolfe.com

KATHY YORK: www.aquamoonartquilts.blogspot.com

FRAN SHARP: www.fransharpdesigns.blogspot.com

TRAVELING EXHIBIT VENUE SCHEDULE

Premiere dates:
July 11 - September 9, 2017
New England Quilt Museum
18 Shattuck Street, Lowell, MA 01852
Opening reception:
July 15, 2017 11 a.m.

October 12-15, 2017
Pacific International Quilt Festival
Mancuso Show Management
Santa Clara, CA

November 9-11, 2017
Original Sewing & Quilt Expo
Minneapolis, MN

December 9, 2017 - February 18, 2018
Fuller Craft Museum
Brockton, MA
Reception: Jan. 21, 2018

March 8-10, 2018
Original Sewing & Quilt Expo
Atlanta, GA

March 15-17, 2018
Original Sewing & Quilt Expo
Lakeland, FL

April 5-7, 2018
Original Sewing & Quilt Expo
Cleveland, OH

June 4-9, 2018
Original Sewing & Quilt Expo
Arlington, VA

July 18-20, 2018
Original Sewing & Quilt Expo
Raleigh, NC

August 3-24, 2018
Experience Fiber Art
The Wilder Building
Rochester, NY

September 2018 (dates TBA)
Pennsylvania National Quilt Extravaganza
Mancuso Show Management
Oaks, PA

October 4-6, 2018
Original Sewing & Quilt Expo
Fredericksburg, VA

46593108R00075

Made in the USA
Middletown, DE
05 August 2017